J/C Art/Des

D0533898

WITHDRAWN

ITEM **015 785 717**

LIONEL CONSTABLE

UXBRIDGE COLLEGE LEARNING CENTRE
Park Road, Uxbridge, Middlesex UB8 1NQ
Telephone: 01895 853326/8

UXBRIDGE
COLLEGE

Please return this item to the Learning Centre on
or before the last date stamped below:

0 7 DEC 2001		

Lionel Constable

759, 2.

LEARNING RESOURCES AT UXBRIDGE COLLEGE

LESLIE PARRIS & IAN FLEMING-WILLIAMS

LIONEL CONSTABLE

The Tate Gallery

ISBN 0 905005 38 4
Published by order of the Trustees 1982
for the exhibition of 24 February–4 April 1982
Copyright © 1982 The Tate Gallery

Published by the Tate Gallery Publications Department
Millbank, London SW1P 4RG
Designed by Sue Fowler
Printed in Great Britain by Balding + Mansell, Wisbech, Cambs

CONTENTS

Note : as this catalogue went to press we learned with regret that Nos.35–46 would not after all be available for exhibition.

Cover : 'Near Stoke-By-Nayland' (detail Cat.No.16)

FOREWORD

This is the first exhibition to be devoted to the work of John Constable's youngest son, Lionel Bicknell Constable. Lionel's paintings were for many years mistaken for his father's work and have only recently begun to be correctly identified. The process of re-attribution is still continuing, and this small exhibition is not intended as a definitive account. Nevertheless, we believe that it will establish the distinctive character of Lionel Constable's work and show him for the talented and charming artist that he was.

We are grateful to Ian Fleming-Williams for agreeing to prepare this exhibition with Leslie Parris, Deputy Keeper of the Historic British Collection. Our debt to all the lenders is considerable but we would especially like to thank Mrs Eileen Constable for her generosity in lending so many items and also her family for all the help they have given.

Alan Bowness
Director

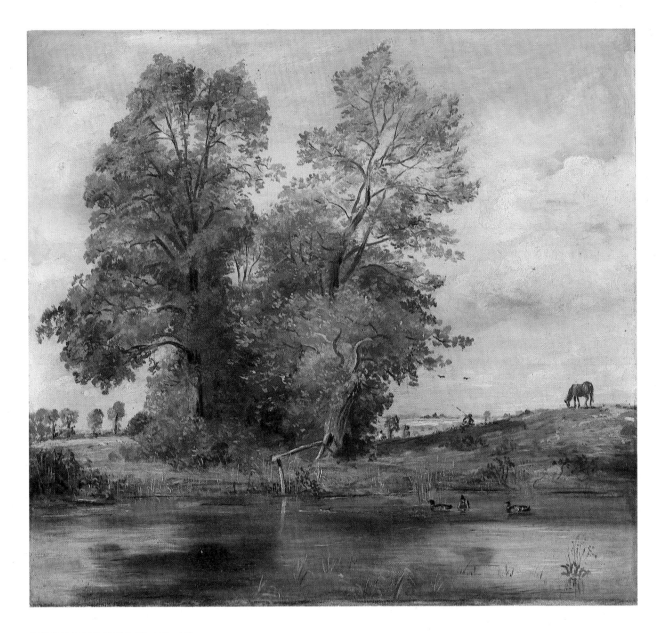

ON THE BRENT (Cat.No.18)

INTRODUCTION Looking for Lionel

Towards the end of his life Lionel Constable does not seem to have talked much about his own painting. An acquaintance writing in 1888 of the household Lionel had shared with his sisters Minna and Isabel in St John's Wood, where they spent their last years 'surrounded by pictures, pets, and flowers', knew only that Lionel had once painted 'a little for amusement' (*The Spectator*, 15 September 1888). This view of his artistic activities was probably encouraged by Lionel himself and if later members of the family suspected him of greater things, they kept their thoughts pretty much to themselves. In 1954 Colonel John Constable, great-grandson of the R.A., mounted an exhibition at Ipswich of 'The Constable Family – Five Generations' which was typically modest in its presentation of Lionel and other family artists. 'Those who see the Exhibition', wrote the Colonel, 'will be disappointed if they expect the work of every member of the family to be as good as that of John Constable ... The collection is made only from those works still remaining in the family, and should be sufficient to indicate the hereditary nature of art'.

Twenty years later, when sifting many hundreds of paintings attributed to John Constable in preparation for the 1976 bicentenary exhibition at the Tate Gallery, it became increasingly apparent to us that a very large number of works existed which were more or less Constabelian in character but did not make sense as the productions of John Constable. Copies and pastiches could usually be distinguished and other doubtfully attributed works could sometimes be redirected towards known associates and imitators. But still there remained paintings which looked very like Constable but did not quite fit our picture of him, enlarged though this now was. A 'Friends and Followers' section at the end of the exhibition was designed to survey parts of this difficult area but it could not take in some of the potentially most interesting items. It did, however, include five drawings by Lionel Constable, one by his brother Alfred and, as last-minute additions, a painting by Lionel (the family's 'Tottenham Park') and a sketchbook which now seems likely to be by Alfred. Some of the drawings were obviously very much in the manner of John Constable but at this stage the oil could not be related to paintings outside the family collection.

After the 1976 exhibition we began to look more closely at what remained in

the family collection of Lionel's work (and also Alfred's) in the hope that clues might be found to the authorship of some of the quasi-Constable paintings which had worried us. From what we already knew, the work of Constable's other children seemed less likely to have been confused with their father's. There were various lines of enquiry, though none were so straightforward as they seem in the retelling.

Because we had been impressed by the similarity of Lionel's pencil drawings to those of his father, we made a number of comparisons between the family's examples and drawings attributed to Constable in other collections; inscribed drawings were especially relevant since examples of Lionel's handwriting, in letters as well as on drawings, were preserved by the family. As a possible item for the Constable bicentenary exhibition Professor Charles Rhyne had kindly told us in 1975 of a dismembered sketchbook in East Berlin (see Nos.35–46) and had pointed out connections between two of its pages and a painting in the Smith College Museum of Art, Northampton, Massachusetts (No.12). Although some of its pages closely resembled John Constable's work, there were also several rather inept drawings and we had not been convinced by the traditional attribution. Comparison of even the better pages with known drawings by Lionel now suggested that he rather than John was the author. This idea was confirmed by the inscriptions on some of the pages, which were clearly in Lionel's hand. There was also evidence that someone had tampered with the dates in the inscriptions, to make '19' (for 1819) out of '49' (for 1849). Even if the year was read as 1819 there was still a problem in reconciling the exact date given on one drawing with John Constable's known movements that year. Having accepted the Berlin sketchbook as Lionel's work, it seemed reasonable to attribute to him paintings which appeared to derive from it: as well as the Smith College picture there were two oils in English private collections (Nos.11, 13); another was to emerge later. Among other Constabelian drawings whose inscriptions pointed to Lionel rather than John was one in the Fogg Art Museum which was evidently the basis of a painting called 'Looking over to Harrow' at the Yale Center for British Art (No.10). The painting itself had characteristics which could be related, we now saw, to Lionel's 'Tottenham Park' in the family collection (No.1).

Meanwhile a number of mid-nineteenth-century photographs had turned up in the family collection, some with Lionel's name pencilled on the back by Hugh Constable, John's grandson. A reference in the family correspondence confirmed

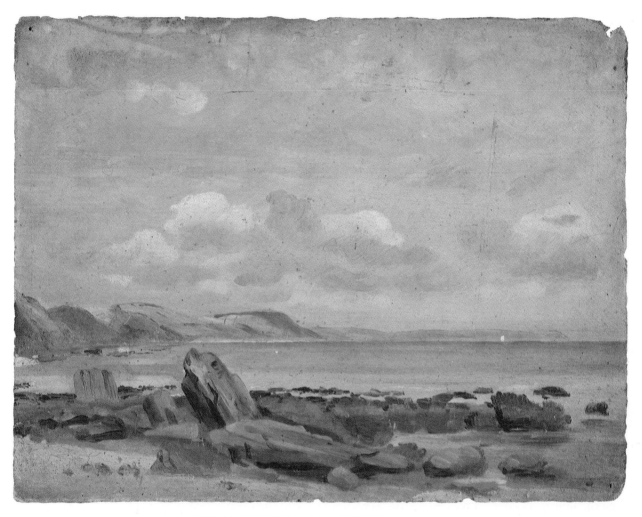

THE COAST NEAR LOOE WITH RAME HEAD IN THE DISTANCE 1850
(Cat.No.3)

that Lionel was engaged in photography at least as early as 1852. Three of the photographs (Nos.57–9) were especially interesting because their subjects tallied very closely with paintings which had hitherto been attributed to John Constable: one with 'An Old Barn' at the Yale Center (No.8) and two with 'A Bridge on the Mole', a subject known in two versions, one of which was in the Johnson Collection at Philadelphia (No.9). As well as depicting the same sites, the photographs showed trees at the same stage of growth as in the paintings and we therefore concluded that the photographic and painted images were more or less contemporary and that Lionel was responsible for both. In addition, one of the photographs of the Mole bridge was inscribed by Hugh Constable (albeit confusedly) 'From a picture by Toby photo by Toby', Toby being one of Lionel's pet-names.

Two oil studies of the Cornish coast (Nos.2–3) also reappeared in the family collection at this time, April 1976. 'Toby' had been written on the back of both and one was dated 1850 and inscribed with the name 'Looe Island'. A distant headland in this dated sketch looked very like the main feature in a hitherto unidentified coastal scene in the Ashmolean Museum attributed to John Constable (No.4). A visit to Looe in November 1977 confirmed a tentative identification made from study of the relevant maps that the headland depicted in both was Rame Head, the rounded point that stands out prominently to the east of Looe. Stylistically, the handling in the Ashmolean sketch and the family's 'Looe Island' was identical. When the latter work, inaccessible during a family move in the summer of 1977, could be re-examined, we found that it was in fact faintly inscribed with the name of the headland. Another painting resurfaced in the family collection once the move was completed. This was 'Falls of the Tummel' (No.5), like 'Tottenham Park' a work Lionel had exhibited at the Royal Academy.

By now we had assembled a group of works which was demonstrably by Lionel Constable and which enabled us to form a more definite idea of the characteristics of his style. With these in mind it was possible to attribute to Lionel a number of works for which no documentary evidence of his authorship existed. However, when we published our findings in *The Burlington Magazine* in September 1978 we deliberately confined such stylistic attributions more or less to one painting, the Tate Gallery's 'Near Stoke-by-Nayland' (No.16). Long regarded as one of John Constable's finest small pictures, it seemed to offer the most severe test of our arguments; if we were right, it was certainly the most

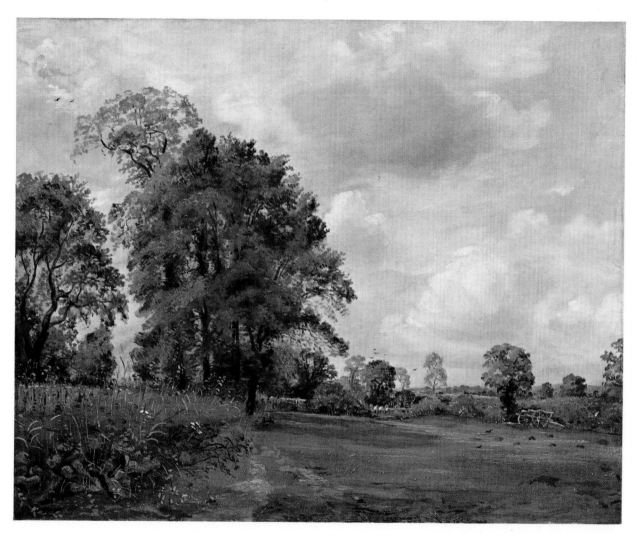

'NEAR STOKE-BY-NAYLAND' (Cat.No.16)

impressive work by Lionel we had come across. In the event, our conclusions were accepted and Lionel shot briefly to the headlines ('Konstchok i England', 'A Star is Born in Art', 'Like father, like son' . . .). In an article in *ARTnews* in November 1978 Charles Rhyne discussed the East Berlin sketchbook in greater detail and published as Lionel's work a drawing previously attributed to John Constable in the Castle Museum, Norwich (No.50). Robert Hoozee made further attributions to Lionel in his *L'opera completa di Constable* in 1979.

* * *

A fairly substantial body of work can now be identified as Lionel's. Of the attributions made since 1978, a number depend on the same kind of evidence as was used in *The Burlington Magazine* article. For example, 'On the Stour' (No.14) and the mezzotint 'Landscape with Church Tower' (No.55) derive from drawings in the 1849 sketchbook, while 'The Way to the Farm' (No.15) is connected with one of Lionel's photographs. A further painting inscribed with Lionel's name has come to light in the family collection (No.7). Other recent attributions have been made on stylistic evidence. Sometimes this seems as compelling as any documentation. For instance, the depiction of the water, ducks and weeds in the previously unrecorded painting 'On the Brent' (No.18) is near enough identical to the treatment of such features in 'Tottenham Park' and the painting stands other close comparisons with Lionel's undoubted work. Again, two paintings in the Johnson Collection at Philadelphia (Nos.19–20) exhibit an idiosyncratic notation which Lionel sometimes used when painting grass and one of them includes rocks painted in a similar way to those in his Cornish coast scenes. Although some of the other works recently attributed to Lionel are less closely related to his undoubted pictures, enough has now been certainly identified for us to begin to form a general idea of him as a painter.

Lionel Constable was an unusual artist. Although he exhibited as a professional at the Royal Academy and made other attempts to sell his work, he did not depend on painting for a living and was able to give it up when interest, nerve, will or whatever failed him after his brother Alfred's tragic death in 1853 (see Chronology). Lionel's painting career was, in fact, very short: probably no more than about eight years, ending in his mid-twenties. Lionel was also unusual in that, apparently oblivious to the contemporary art scene, he seems to have taught himself landscape painting almost entirely by studying his father's work. Many were of course aware of John Constable's work by the 1840s but Lionel

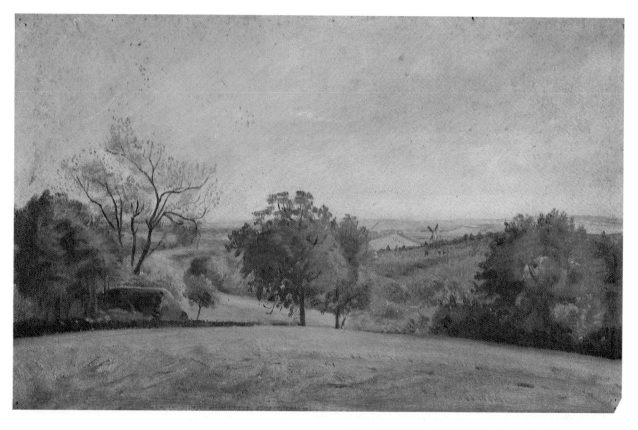

LANDSCAPE WITH BARN AND WINDMILL
(Cat. No. 7)

surrounded himself with the sort of pictures by his father that remained unknown to others until the 1870s and 1880s. Having failed to create much interest in the studio sale of 1838, most of John Constable's early paintings and less formal works, including his outdoor oil sketches, stayed in the family until Lionel and his brother Charles began sending things to auction in the late 1860s. The works by John Constable which were being collected and imitated before that time were largely the exhibition canvases of the 1820s and 1830s, together with David Lucas' mezzotints after Constable. The palette knife technique of the artist's late works proved especially popular with imitators. By contrast, Lionel seems to have absorbed himself in the quieter, more intimate paintings of his father's Suffolk and early Hampstead years. In a division of the family collection between the five surviving children (Minna, Charles, Isabel, Alfred and Lionel) in 1847–8, an event that may itself have given impetus to his painting, Lionel chose for himself such works as 'View at Epsom', the study of 'The Mill Stream' and 'Admiral's House, Hampstead', to name three examples which are now in the Tate Gallery.

Although as an artist Lionel modelled himself on his father, his paintings have their own distinctive character. Of modest ambition, he invariably worked on a small scale, his largest canvases being only about 14 × 18 inches. He generally preferred a lighter colour key to his father and made certain colours peculiarly his own: pinky-mauves in clouds and on distant hills; intense cerulean blue for clear skies; a pale yellowish khaki for dry, grassy foregrounds; purple-grey tones for rocks. Usually he applied paint more thinly than his father and with a lighter, more delicate touch; little of the urgency and power of John Constable's handling is to be seen in his work. Areas of brownish underpainting are sometimes left exposed on the canvas, especially in the foregrounds of his pictures, where they may be lightly covered with a scattering of tall grasses and flowers. The heads of such grasses often fall into a shape resembling an italic 'f' with added cross-strokes at the top, a shorthand notation amounting almost to a signature (see Figs.i–iv). Lionel was either less able or less concerned than his father to show the structure of trees and clouds and was less responsive to three-dimensional form generally. The anatomy of trees is frequently masked in Lionel's paintings by flat masses of foliage and if branches do emerge they seem insubstantial. As if to compensate, Lionel pays special attention to outlines: the outer foliage of his trees is frequently indicated with innumerable small touches or dabs of the brush. He seems particularly fascinated by the silhouettes of trees

Fig.i (detail Cat.No.6)

Fig.ii (detail Cat.No.10)

against the sky. It is possible that Lionel's experience as a photographer had something to do with the two-dimensional bias in his painting, though we know little about the actual use he made of photographs when painting. An even less certain factor is a damage he is reported to have suffered to one of his eyes at an early age (see Chronology).

Certain types of composition recur in Lionel's work. The focus of interest in many of his paintings is a strip of ground running across the picture in the near middle-distance – a band of trees, for instance, often with one dominant tree – which is separated from the spectator by a relatively empty foreground, a meadow, say, or a stretch of water. A variant design with a less extensive foreground sloping from left to right is sometimes found. In some works there is little or no foreground and a low horizon underlines what is essentially a cloud study. The staffage of his more finished landscapes is frequently conspicuous. Small white-clad figures pop into view and if more than one appears they tend to line up in military fashion; even his moles are regimented, judging by the regular spacing of the mole-hills in 'Near Stoke-by-Nayland' (No.16). Trees in distant hedgerows are also sometimes disposed rather formally. Lionel lacked his father's feeling for random spacing.

Fig.iii (detail Cat.No.16)

Although Lionel often chose to paint subjects similar to his father's, he rarely worked in the same places, Hampstead being the chief exception. Nor did he share his father's intense attachment to a few localities. Lionel appears to have been at home wherever he found himself – from Cornwall to Scotland – and as a result it is not always easy to identify the subjects of his pictures, especially when recognisable topographical features are often absent. Having spent long years under the wrong flag, some of his works bear fictitious titles referring to the Stour valley.

Any attempt to characterise Lionel Constable must still be provisional, however. Although a variety of work by him is now known, his full range is still uncertain. There are, for example, paintings which have perhaps only one or two of the features described in the foregoing paragraphs and which do not seem close enough to Lionel's unquestioned work for one to feel quite sure of their attribution. Some of these are included in the present exhibition as Nos.28–33. One of the purposes of this exhibition, in fact, is to bring together for the first time paintings which are normally widely dispersed, in the hope that close comparison will remove such doubts or suggest other explanations. One alternative to be considered is that some of the paintings which at present can

Fig.iv (detail Cat.No.20)

only be tentatively linked with Lionel are actually by his elder brother Alfred Constable. Alfred's letters, which survive in far greater quantity than Lionel's, suggest that he too modelled himself as an artist on his father. Already in 1843 we hear of him at Flatford making 'a little oil sketch on the meadows below fen bridge'. Back in the Stour valley in 1846, he tells Lionel that he is 'doing a picture of the Harvest men' which he thinks will do for the Royal Academy (where he exhibited from 1847 to 1853) but that he is worried that it may be thought 'Papare', that is, too much like his father's work. His letters are dotted about with references to 'clouding' and with such ultra-Constabelian remarks as 'I never touch my pictures in doors'. Others, apparently, approved. In 1847 his cousin Jane Anne Luard bought his first R.A. exhibit, 'Landscape', and wrote to tell him that now she could examine it properly she could see 'how much truth there is in it & that particular out of door look that is of inestimable value'. Neither this nor any other of Alfred's exhibited works has been discovered. In fact, only two paintings of any sort have been identified as his: a rather dull landscape in the family collection and an oil study in another private collection. They are very different from each other and neither seems to relate to other paintings that may be by him. So far Alfred's drawings have not given a lead either. Most of the works now attributed to Lionel have been identified among pictures once thought to be by John Constable. Since there is no reason to think that Alfred's paintings were ever destroyed, they too may await discovery among the doubtful works that still surround John Constable's oeuvre and, indeed, among the doubtful works which now surround Lionel's.

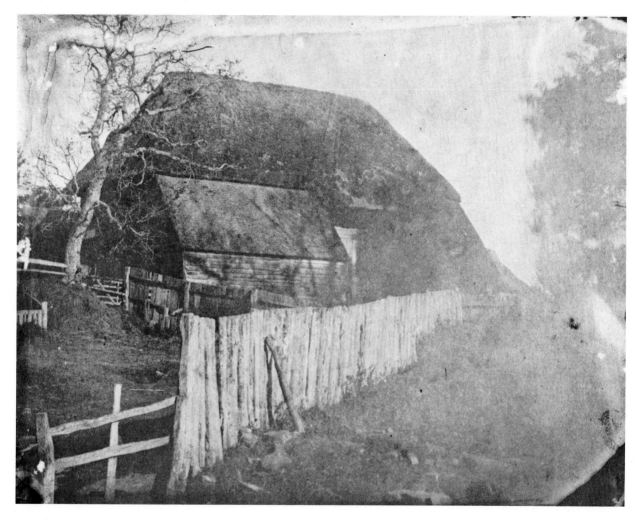

AN OLD BARN (Cat.No.57)

CHRONOLOGY

1828

2 January : born, 6 Well Walk, Hampstead, seventh and last child of John and Maria Constable ; godparents include C. R. Leslie R.A.
23 November : death of his mother.

1837

31 March : death of his father. Golding Constable (John's brother) and Lancelot Archer-Burton appointed guardians of the Constable children, who are all minors.

1838

The Constable children move to 16 Cunningham Place, St John's Wood. Around this time Lionel attends school at East Sheen.

1841–*circa* **1844**

Attends Stoton & Mayor's school, Wimbledon. His brother Alfred (1826–53) encourages him to draw about this time. Family letters indicate that Lionel was having trouble with one or both of his eyes in 1841 and also 1846.

1845

October : sketchbook with one page bearing this date, now in Louvre (see No.53).

1846

Summer : stays with a Mrs Nodin at Ashcott near Glastonbury, Somerset (see No.34).

1847–8

Attends F. S. Cary's School of Design (Sass's Academy) in Bloomsbury, where Alfred has studied earlier.

1849

May: exhibits at Royal Academy for first time: 40, 'Landscape'; 358, 'A view near Twyford'. Sketchbook with dates ranging from 18 May to 21 September, now in East Berlin (see Nos.35–46).

1850

January: exhibits for first and only time at British Institution: 342, 'Evening', size with frame 16 × 20 inches.
May: R.A. exhibits: 14, 'Landscape'; 516, 'A stormy day'; 630, 'Tottenham Park' (No.1); 975, 'An ash tree'.
July: visits Cornwall (see Nos.2–4, 47).
September–December: visits U.S.A. (see Nos.48a–b).

1851

May: R.A. exhibits: 13, 'On the coast of Cornwall'; 1039, 'Entrance to Looe harbour, Cornwall'.
Summer: visits Scotland (see Nos.5, 49).

1852

May: R.A. exhibits: 1129, 'Falls of the Tummell, Inverness-shire' (No.5); 1293, 'View on the Thames, near Pangbourne, Berkshire'.

Summer: visits Devon with Alfred (see No.6).
10 November: first known reference to Lionel as photographer (see p.105).

1853

May: R.A. exhibit: 729, 'A study' (under 'Drawings and Miniatures').
19 November: Alfred Constable is accidentally drowned in the Thames at Goring; Lionel is with him at the time and is said to have suffered a serious illness following the accident.

1855

May: last R.A. exhibits: 271, 'A barn, in Sussex'; 1358, 'Entrance to a wood'. Lionel apparently gives up painting around this time and devotes himself to sailing and photography.

1887

20 June: dies at 64 Hamilton Terrace, St John's Wood, where he has lived for some years with his sisters Isabel and, until her death in 1885, Maria Louisa ('Minna'). Bequeaths his estate, including freehold property at Felixstowe and East Bergholt and a London leasehold, to Isabel. His paintings eventually pass to the children of his brother Charles Golding Constable, the only one of John Constable's children to marry. Many works are sold by Charles' second son, Hugh Golding Constable (1868–1949); a few descend through him to the present generation.

FIVE LETTERS

Only seven letters by Lionel Constable, and a fragment of an eighth, have been found. The five most interesting are published here for the first time by kind permission of Mrs Eileen Constable. The remaining letters are: to Alfred Constable, n.d. (early 1840s); to Minna Constable, 24 October 1867; and a fragment of a letter to Minna and Isabel Constable, 4 June 1873. In the following transcriptions Lionel's spelling and punctuation are retained but extra space is introduced between unpunctuated sentences. Doubtful words are enclosed within square brackets, deletions within pointed brackets.

1. To Alfred Constable, 5 June (no year)

The date of the visit to Derbyshire and Lancashire described in this letter is not known but a watercolour which was probably made on the same tour has survived (No.52). Lionel's companion, 'Mackey', has not been identified. Mary Sanford was presumably a relation of Lionel's aunt Louisa Sanford.

June 5<u>th</u> Lancashire

Dear Alfred

 I shall not venture to give you my address for Mackey is just like a pea in a tobacco pipe never still
I have already slept in 4 different places, I went first to Bakewell, then to Glossop, then to Fleetwood and now at Broughton. The other day I was walking all about Manchester but I did not stumble on Mary Sandford I think Manchester a fine ci⟨t⟩ty I went to Castle town and perhaps, you have yeard talk of⟨f⟩ The famous Peak Cavern well ⟨I⟩ we explored it with a guide it was something like going into a mine we had to put caps on and carry lights The guide said it was the finest cavern in the world, Mackey said it was only the finest one in England but not in the world by any means, but after all the guide seemed to be interested in Mackey's explaining finer caverns to him, I share nearly all the expences with Mackey, and I must tell you that the express first [?calls] does not suit⟨e⟩ my laughable income I have done no

[22]

sketches, but I have done something I have spent plenty of money I shall soon have to write to you to send me a 50£ note, I am in a dreadful hurry to get to bed Yours Truly Lionel, B, Constable

It is curious to see Helvellyn in the distance covered with snow in june for I have not seen any all the winter

2. *To Alfred Constable, about 25 September to 3 October 1850*

This letter and the following one describe Lionel's visit to America in the autumn of 1850. His friend 'Jack' has not been identified.

Wrote this letter on board about Sep<u>ber</u> 25th
Arrived at New York Oct<u>er</u> 1 PM 1850
I do not think this letter will leave New York till Oct<u>ber</u> 5. Satur day,

Dear Alfred

Oct.<u>ber</u> 3<u>rd</u> 1850.
I have got my money all wright from the bank here. love to all.

The voyage was a long one and we had a good deal of bad weather

I have now nearly got to the end of the voyage, I shall not be able to give you any account of America in this letter for Jack thinks of starting for the

country the instant he lands so that I shall get my letter finished befor I reach New York I will tell you the plans we have settled on when we get to New York. We first go by steam packet to Albany from that place to Buffalo by railroad, then take the steam boat again and go by the lakes to a place called Chicago the first lake is lake Erire, then lake Huron and lake Michigan alto gether about 2000 miles it can be done for less than £3 counting food &c, &c, Jack expects to get a great deal of shooting and by the accounts I hear he certainly will their being plenty of game wild deer and even bears, horrid. I have not done any sketching on this voyage it being impossible to find a quiet place I have scene some beautiful effects of sunsets and moon l⟨i⟩ights The captain is very much liked he is the only one on the line that allowes the steerage a portion of the quarter deck to walk upon. After you left us three steam boats towed us as far as the Nor we had a fair wind all the way to Portsmouth I had a beautiful view of the coast almost all the way to Landsend, the wind being off the land the vess⟨a⟩el came close in so that you could see the people on the shore. We remained in the mouth of the channel for about a week the weather being very unfavourable with a head wind and blowing hard which made us both very ill scarcely eating any thing for about a week after that we began to get our regular appetite we ought to have brought potatoes and biscuit with us, the biscuits that are served out being dogs biscuits and not eatable. I made an arrangement with the cab⟨b⟩in passengers cook to let us have the odds and ends that came out from the cabin finding he supplied us regularly every day with bits of potatoes &c, &c, which he put into our sauspan we gave him half a crown each as a presant which considerable improved our mess. I remain on deck the whole day even if it is bad weather finding I have quite enough of the steerage in the night I manage to sleep very well considering the tremendous noise that is keept up untill 3 Oclock P.M. there is a man that makes a noise on the fiddle then the songs they sing are very queer with noisey chorrusses. There is a young man that is working is way over as lad to the steward, he cleans candlesticks, knives, lamps, &c. he takes portraits in pencil he has done a good many on board for 6d each I talked a good deal to him I find he only ⟨comes⟩ goes those voyages in the summer for pleasure he lives in New York and gets [?8s] a day as carver and gilder besides portraits that he does in oils and sea pieces. September 10th 11th I experienced a hurricane for the first time in my life it was very grand. I certainly felt the sentance that is so often quoted, "that its

only a plank between life and death." it began very gradually from the ship
being all under canvas till it was reduced to her being ⟨. . .⟩ under her main
spencer, close reefed main top sail, and gib In the night a heavy sea broke
over her which carried away some part of her bulwarks, what with the noise of
the sea rushing about on the deck, and the howling of the wind [?thru] the
rigging, made the steerage passengers think it was all up with them some of
the men seemed more timid than the woman most of them were
mad, amongst the voices, I could catch a few sentences, one was, we shall all
die together &c c., I shall write another letter most likely when I get up into
the country. I shall then be able to tell you when I shall come home I fancy it
will be the end of December I find that the ship take you back for £2.
Yours Faithfully, Lionel Constable

3. *To Maria Louisa Constable ('Minna'), 16 November 1850*

For drawings made by Lionel on the visits to Niagara Falls and Milwaukee
mentioned in this letter, see Nos.48a–b.

 Dated at New York, Saturday 16th of November 1850
Dear Minna
I thought you might like to hae a letter to let you know that I now thought of
coming home my money getting rather short. I left Jack at a place called
Milwaukee more than a thousand miles from New York it took us nearly
three weeks, during that time he fell in with three brothers that were ⟨was⟩
going to the same place. They were going to work in the woods all the winter
cuting down trees and in the spring floating them down rivers. Jack seemed
delighted with the thoughts of it and has engaged himself to work with
them he does not seem to care how hard the work is that he does he will get
very good pay for it £5 a month a good hand will get £10. he wanted me to
stop the winter, but I did not think it would quite do for me I think it was
my best plan to return to old England, and I am now on my way to New York,
I expect to get there in 10 days time I have already been traveling 13 days, I

am now going along in a canal boat and this letter passes away the time, before I post it I will let you know the name of the vessel I shall come to England in. On my way back I took in Niagara Falls I thought them very fine and Robert Leslies pictures very like them. You will be surprised to here that the country for so many miles I have seen is very flat, swampy, and unpicturesque. Did Alfred receive my last letter In coming off the ship I found that a man had taken my cord belonging to my box and it was entirely oweing to the eye that was spliced at ⟨the⟩ one end of it and a real knot at the other end, that I was able to get it for that proved to him that it was not his, so very few landsmen being able to splice. On board the ship I saw in a young mans pocket book a little wood cut written underneith it was, painted by J Constable R.A. A view on the Stour. It was a subject I had never seen, but it was very pretty. I stoped a day or two at Milwaukee after I had left Jack waiting for a steam boat one of the evenings their there was a alarm of fire given. all the bells rang in the place. the engines are very different from the London ones. they have a long rope attached to them and any one may lay hold of it and run I ran along with one but found there was no fire, I have seen many ruins, most of the houses being built of ⟨W⟩wood so that when they catch fire it must be impossible to save them. I have had two or three very pleasant companions some of them going the same way as my-self one was a Scotch man about my age he had been over here two years being too poor to live in Scotland he came over here he thinks of going to Callifornia but it is a dangerous voyage and a very long, and expensive one, Jack had to give it up it requiring £40 to get there. When I bought this piece of paper I asked the man for foreign letter paper, but he seem⟨ed⟩s to have understood me as ruled paper by what he has given me. Tel Alfred I wish him many happy returnes of his birthday. it is no use my getting any here I can get nothing different here than from London and the articles are very inferior to the London ones with love to all believe me to be

> Yours affectionately
> Lionel Constable

My ship sails on Saturday 16th of November 1850
> name of ship. The London. for London
> > Capt Hebard. Burthen 1500 tons.

4. To Maria Louisa Constable ('Minna'), n.d. (before 14 November 1856)

This letter and the following one were written during a visit to Hastings by Lionel and his sister Isabel. They are especially interesting for their accounts of Lionel's photography. 'Gip' was Lionel's dog.

Dear Minna

Isabel is too lazy to write to you to night so I once more take up pen. I do not know whether Isabel told you that she went with me to see & hear [? Woodin] she was amused only very midling. There has been no effects over the sea as yet for Camera, camera waits patiently looking out of window but has not seen anything at present it will be curious if it has to be packed up without bringing away a cloud, but I shall give it another week. Isey & myself went fishing with a boatman the other day we (Isey & I) caught nothing, but the man caught a quantity of dabs & dogfish & one sweet William we had a cuple of dabs for tea & Isable liked them very much & wants to have them again – Poor Mrs Clark it will make quite a void amongst your friends. I am glad I gave her that poor photograph of High Trees farm. Give Gip nothing but plain oatmeal unless you like to mix it with scraps from the table, ask for fresh oatmeal for after it has been ground 3 or more months it becomes all alive & is not fit for food. I mean to get it at the Mill when I come home at I think 6ᵈ a gallon. So I shall find George at home when I come back. I hope I shall get a little printing in this winter I should like to before George & Drew get me I wonder how Drew is I have only heard once from him this country trip very different from last I do not advise your coming down here but if you dont care about the expence & can leave home without its being a care bring Couzy Ward as I have plenty of time.

<div align="center">Yours One of the Pets</div>

UXBRIDGE COLLEGE
LEARNING CENTRE

5. To Maria Louisa Constable ('Minna'), 14 November 1856

Hastings Nov 14ʰ 56

Dear Minna

Isabel wishes to come home next Tuesday & I myself am longing to see old
Gip I left her with the country look I guess now her paws & shirt front are
dirty or Londonny. M^{rs} Hills says we may stay by the day if we like, paying at
the same rate as for the week I do not know what that ⟨h⟩is but I guess
somewhere about 4 or 5 shillings so that I should not be surprised that if there
were effects on Tuesday you would not see us till Wednesday or Thursday, it
will surprise you when I tell you that there has been no effects here all the time
we have been, though very beautiful weather The collodian I have got is
splendid never had better & it will be a pitty to bring it home again to let it
⟨lie⟩ lay dormant all the winter & spoil. but do not think from this that I wish
to spend another whole week here, far from it. I ass⟨h⟩ure you if it was not for
camera I would not be another day away from old Gip. There has been a sloop
on shore here I mean just in front, when I am glad to say camera did its duty,
with the exception of that Sloop I have nothing to shew I do not know
⟨wether⟩ whether you will be able to get anything tangable out of this note,
but I have tried to explain our plans & intentions & if I have not succeeded
you must excuse me for I have had Herrings for tea.
I have just room to add that Isabel has got you mania ⟨of⟩ when you are in
the country of runing out after every meal which has knocked me up & her self
too, for we have both a pain in the back ⟨from⟩ and the exertion of writing our
thoughts to you is great to

Your Pet

CATALOGUE

The history of the attribution of each work is briefly indicated in a line beginning '*Attr:*'. The abbreviations 'JC' and 'LBC' are used for John Constable and Lionel Constable. Dates cited refer only to published attributions.

In the 'Literature' section of the catalogue entries, reference is made to the published material on Lionel Constable and to selected earlier works on John Constable when these help to establish the provenance of the exhibits or are otherwise relevant.

All letters quoted are in the collection of Mrs Eileen Constable. Original spelling and punctuation are retained; pointed brackets indicate deletions in the originals.

EXHIBITIONS

Camberwell 1954	*The Constable Family – Five Generations*, South London Art Gallery, Camberwell 1954 (this smaller version of the 1954 Ipswich exhibition was subsequently shown in Sunderland, Middlesbrough, Birkenhead, Southsea, Worcester, Leamington and Blackpool, where it closed in September 1955)
Ipswich 1954	*The Constable Family – Five Generations*, Christchurch Mansion, Ipswich 1954
Leeds 1913	*A Loan Exhibition of Works by and after John Constable, R.A. (1776–1837)*, City of Leeds Art Gallery 1913
Leggatt's 1899	*Pictures & Water-Colour Drawings by John Constable, R.A.*, Leggatt's 1899
R.A. 1964–5	*Painting in England 1700–1850 From the Collection of Mr and Mrs Paul Mellon*, Royal Academy 1964–5
Richmond 1963	*Painting in England 1700–1850, Collection of Mr & Mrs Paul Mellon*, Virginia Museum of Fine Arts, Richmond, Virginia 1963
Washington 1969	*John Constable, A Selection of Paintings from the Collection of Mr and Mrs Paul Mellon*, National Gallery of Art, Washington 1969
Wildenstein 1937	*John Constable, R.A., His Origins and Influence*, Wildenstein 1937
Yale 1965	*Painting in England 1700–1850 From the Collection of Mr and Mrs Paul Mellon*, Yale University Art Gallery 1965

LITERATURE

Holmes 1902	C. J. Holmes, *Constable and his influence on Landscape Painting*, 1902
Hoozee 1979	Robert Hoozee, *L'opera completa di Constable*, 1979
P. & F-W. 1978	Leslie Parris & Ian Fleming-Williams, 'Which Constable?', *The Burlington Magazine*, CXX, 1978, pp.566–79
Parris 1981	Leslie Parris, *The Tate Gallery Constable Collection*, 1981
Rhyne 1978	Charles Rhyne, 'Lionel Constable's East Berlin sketchbook', *ARTnews*, Vol.77, No.9, 1978, pp.92–5
Shirley 1937	C. R. Leslie, *Memoirs of the Life of John Constable, R.A.*, edited and enlarged by Andrew Shirley, 1937

PAINTINGS

Nos.1–15 are oil paintings for which fairly definite evidence of Lionel's authorship exists and this is briefly indicated in the entries. Nos.16–27 and, with less confidence, Nos.28–33 are paintings attributed to Lionel on stylistic grounds; detailed analysis of these is not attempted here, though a few stylistic features are noted in the catalogue entries.

1 TOTTENHAM PARK exh.1850

Inscribed on a damaged label on the stretcher 'Tottenham [.]
B. Constable'
Oil on canvas, $18\frac{1}{4} \times 14\frac{1}{8}$ (46.4 × 35.9)
Attr: always LBC.
Prov: always in the Constable family.
Exh: R.A. 1850(630, 'Tottenham Park'); Ipswich 1954(172);
Camberwell 1954(142); *Constable: Paintings, Watercolours & Drawings*,
Tate Gallery 1976(345a); *The Other Constables*, Camden Arts Centre
1976(Lionel Constable No.7).
Lit: P. & F-W. 1978, p.571.
Mrs Eileen Constable

This is one of two works which can be identified as having been exhibited by Lionel at the Royal Academy, the other being No.5 below. The subject is probably Tottenham Park near Marlborough, Wiltshire, domain of the Marquess of Ailesbury. 'No traveller', advised Murray's *Handbook*, 'should neglect an opportunity of visiting this sylvan tract . . . which still displays a magnificence of forest scenery peculiarly attractive to the artist, who, among its majestic oaks and graceful beeches, may realise the paintings of a Gainsborough or Hobbema' (*Handbook for Travellers in Wiltshire, Dorsetshire, and Somersetshire*, quoted from fourth edition, 1882, p.43). A slight pencil drawing in the Constable family collection of trees at a water's edge is inscribed 'July. Friday the 7th afternoon Tottenham Park'. 1848 is the most likely year for this conjunction of day and date. The drawing is not directly related to No.1 but presumably Lionel made others on the same visit which were used as the basis of this painting.

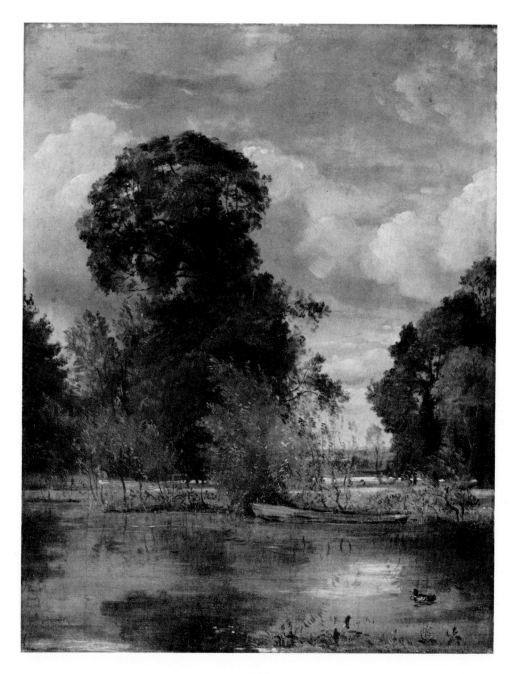

2 LOOE ISLAND WITH RAME HEAD IN THE DISTANCE 1850

Inscribed on the back '[. . .]iday the 12$\underline{\text{h}}$ July 1850. Looe island, R[.] distance, at low tide.' Also inscribed 'Toby', i.e. Lionel, in a later hand. The centre of the top edge is damaged, hence the gap in the inscription. The missing words are supplied on the back in a third hand: 'Rame Head in the'.
Oil on board, $9\frac{1}{8} \times 10\frac{1}{4}$ (23.2 × 26)
Attr: always LBC.
Prov: always in the Constable family.
Lit: P. & F-W. 1978, p.571.
Mrs Eileen Constable

See the entry on the next item, No.3.

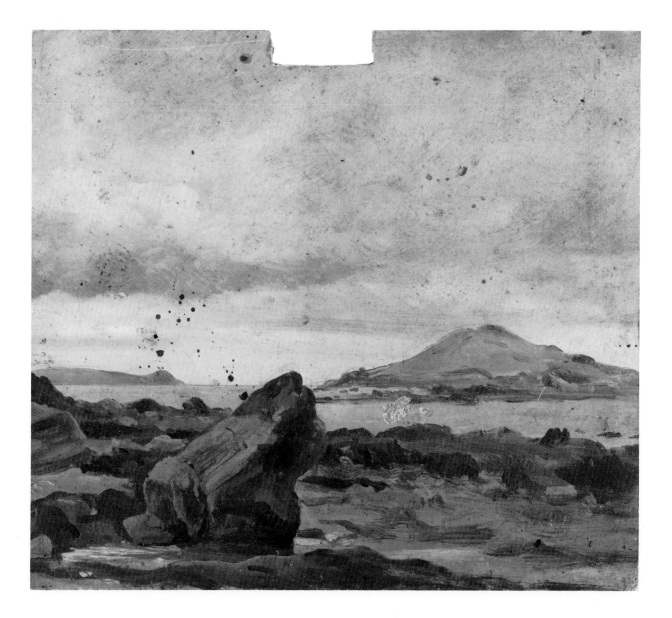

3 THE COAST NEAR LOOE WITH RAME HEAD IN THE
 DISTANCE 1850

Inscribed on the back in a later hand 'Toby', i.e. Lionel.
Oil on board, $9\frac{3}{8} \times 12\frac{1}{4}$ (23.8 × 31.1)
Attr: always LBC.
Prov: always in the Constable family.
Lit: P. & F-W. 1978, p.571.
Mrs Eileen Constable

Drawings in the family collection made by Lionel on the same visit to
Cornwall include a watercolour of Redding Point from Rame, dated
2 July 1850 (No.47 below) and a pencil drawing of the Cheesewring on
Bodmin Moor, dated 19 July 1850. Lionel exhibited two Cornish subjects
at the R.A. in 1851: 'On the coast of Cornwall' and 'Entrance to Looe
harbour, Cornwall'. The following oil study, No.4, was probably also
made on the 1850 visit.

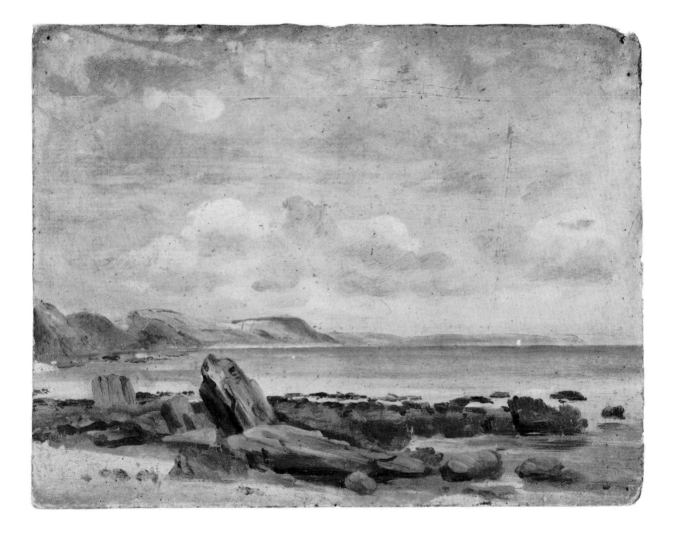

4 RAME HEAD, CORNWALL 1850

Inscribed by Hugh Constable on a label on the back: 'this sketch of
Headland – Rocks in foreground – green sea by John Constable R.A.
was inherited by me from Miss Isabel Constable, my aunt, daughter of
the artist: Hugh Constable Grandson of the artist 22.11.1905
London this picture measures 12″ × 7″'.
Oil on board, $7\frac{1}{16} \times 13$ (18 × 33)
Attr: JC until 1978.
Prov: probably sold by Hugh Constable 1905; . . . ; presented to the
Ashmolean Museum, Oxford by Sir Michael Sadler in memory of Lady
Sadler 1931.
Lit: P. & F-W. 1978, p.572; Hoozee 1979, No.592.
The Visitors of the Ashmolean Museum, Oxford

Like Nos.2–3 this study depicts Rame Head but from closer to.
Presumably it also dates from Lionel's visit to Cornwall in the summer
of 1850.

5 FALLS OF THE TUMMEL exh.1851

Inscribed on an old label on the stretcher 'Falls of The Tummell
Inverness-shire L.B.Constable –'.
Oil on canvas, 13 × 17 (33 × 43.2)
Attr: always LBC.
Prov: always in the Constable family.
Exh: R.A. 1852 (1129, 'Falls of the Tummell, Inverness-shire');
Ipswich 1954(173); Camberwell 1954(155).
Lit: P. & F-W. 1978, p.571.
Mrs Eileen Constable

Lionel visited Scotland in the summer of 1851. Two watercolours by him
of Wemyss Bay on the Firth of Clyde, one dated 14 June 1851, are in the
family collection (see No.49).

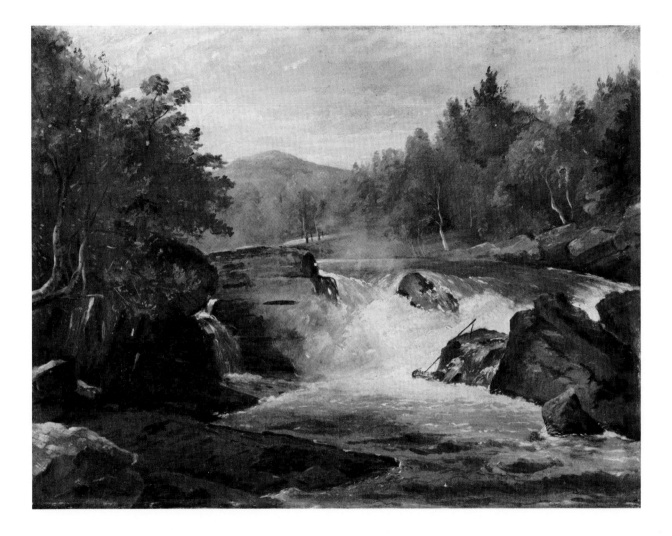

Inscribed on the back 'On the Sid near Sidmouth'.
Oil on paper laid on board, $9\frac{3}{8} \times 12$ (23.8 × 30.5)
Attr: JC until 1978.
Prov: Ella Constable (Mrs Mackinnon); Hugh Constable (thus far according to an inscription by Hugh dated 22 November 1905 recorded in the 1913 Leeds exhibition catalogue but no longer on the back of the picture); . . .; Heinemann Gallery, Munich 1910; Sir Michael Sadler by 1913 and sold by his daughter-in-law, Mrs Michael Sadleir, Christie's 27 October 1961(75), bt. Colnaghi for Mr and Mrs Paul Mellon.
Exh: Heinemann Gallery, Munich 1910; Leeds 1913(103); *John Constable 1776–1837*, Guildhall Art Gallery 1952(29); Washington 1969(39).
Lit: Shirley 1937, pp.lx, 33; P. & F-W. 1978, p.577; Hoozee 1979, No.588; Parris 1981, under No.53.
Yale Center for British Art (Paul Mellon Collection), New Haven

The river Sid rises above Sidbury in Devon and flows into the English Channel at Sidmouth. The inscription on the back, privately noted by Graham Reynolds as long ago as 1956, was shown to one of the present compilers by Charles Rhyne in October 1978. At that time the painting was known simply as 'Brook, Trees and Meadows'. Since John Constable never visited Devon, the inscription tended to confirm the attribution to Lionel which had been made only on stylistic grounds in the September 1978 article. Correspondence which has since come to light in the family archive shows that in the summer of 1852 Lionel and Alfred sent their brother Charles, then based on Bombay, various sketches made near Sidmouth including one of Sidmouth Bay on a July afternoon. At the R.A. the following year Alfred exhibited a work, listed under 'Drawings and Miniatures', entitled 'On the Devonshire coast'. The two brothers had evidently visited Devon together in the summer of 1852. The resemblance of parts of No.6 to Lionel's 'Falls of the Tummel' (No.5) and the presence of his characteristic italic 'f' plant notation still point to him rather than Alfred as the author.

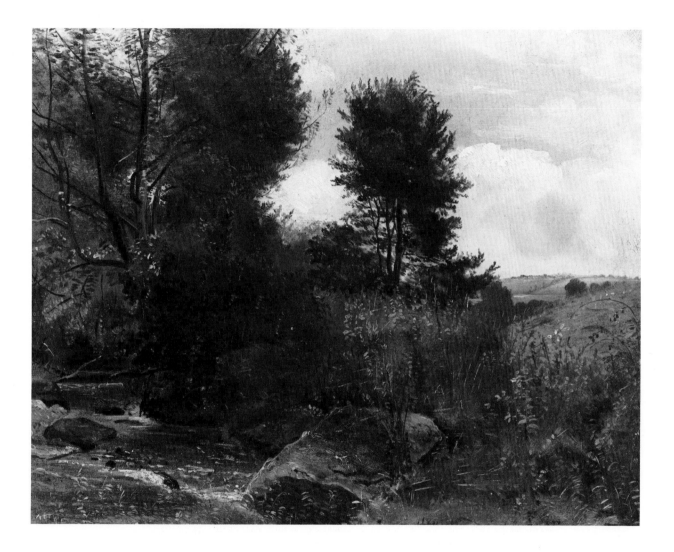

7 LANDSCAPE WITH BARN AND WINDMILL

Inscribed 'Toby', i.e. Lionel, in a later hand on the back.
Oil on paper, $9\frac{5}{8} \times 15\frac{3}{8}$ (24.5 × 39)
Attr: always LBC.
Prov: always in the Constable family.
Mrs Eileen Constable

This painting only came to light in the family collection in 1980.
See No.23 for a similar landscape with a windmill.

8 AN OLD BARN

Oil on board, $9\frac{5}{8} \times 15\frac{3}{8}$ (24.5 × 39.1)
Attr: JC until 1978.
Prov: one of a group of works sold by Ella Constable (Mrs Mackinnon)
through Leggatt's in the 1890s to Sir Henry Newson-Smith, Bart.; sold
by his son Sir Frank Newson-Smith, Bart., Christie's 26 January
1951(26), bt. Leggatt; Charles Russell, sold Sotheby's 30 November
1960(101), bt. Colnaghi for Mr and Mrs Paul Mellon.
Exh: Richmond 1963(91); R.A. 1964–5(61); Yale 1965(25);
Washington 1969(14).
Lit: P. & F-W. 1978, p.572; Hoozee 1979, No.566.
Yale Center for British Art (Paul Mellon Collection), New Haven

This painting is closely related to a photograph by Lionel Constable,
No.57 below. In 1855 Lionel exhibited 'A barn, in Sussex' at the R.A. but
it is not known whether it was connected in any way with this work.

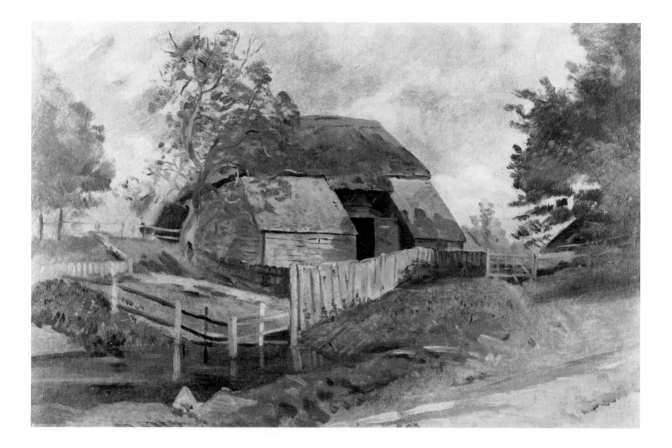

9 A BRIDGE ON THE MOLE

Oil on (?) panel, $9\frac{15}{16} \times 11\frac{15}{16}$ (25.4 × 30.3)
Attr: JC until 1978.
Prov: sold by Hugh Constable to Leggatt's 1899 (according to their
printed label on the back); probably acquired from Leggatt's 1899
exhibition by Alexander Young, from whom bt. by Agnew's July 1906;
bt. from Agnew's by J. G. Johnson, August 1907.
Exh: Leggatt's 1899 (5, 'A Bridge on the Mole' or 67, 'Bridge on the
Mole').
Lit: Holmes 1902, p.241; Lord Windsor, *John Constable R.A.*, 1903,
p.209; Shirley 1937, pp.28. 36; P. & F-W. 1978, p.572; Hoozee 1979,
No.568.
The John G. Johnson Collection, Philadelphia

Two photographs by Lionel Con-
stable of the subject survive,
Nos.58–9 below. A more finished
version of the painting (Fig.v)
was last recorded in the collection
of Carroll Carstairs in 1938. This
measured $12 \times 15\frac{3}{4}$ (30.5 × 40).
The river Mole rises near Crawley
in Sussex and runs through the
Dorking gap to join the Thames
at East Molesey; the bridge in
No.9 has not yet been identified.

It is interesting to note that
while Sir Charles Holmes ac-
cepted No.9 in 1902 as a painting

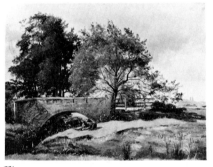

Fig.v

by John Constable of 1807, he
described it as 'A singularly
modern-looking example of Con-
stable's early efforts at realism'.

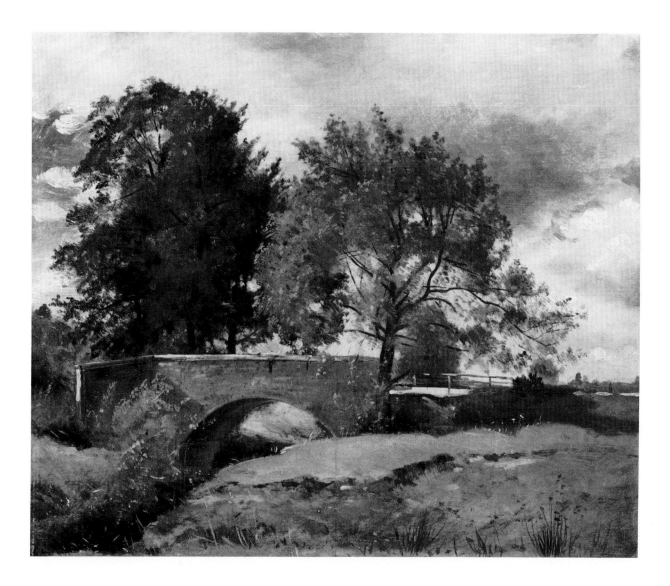

10 LOOKING OVER TO HARROW

Oil on canvas, $13\frac{1}{2} \times 17$ (34.3 × 43.2)
Attr: JC until 1978.
Prov: . . .; R. C. Gunter by 1914; his daughter, the Hon. Mrs K. Stourton; purchased from John Mitchell & Son by Mr and Mrs Paul Mellon 1969.
Exh: Washington 1969(not in catalogue).
Lit: P. & F-W. 1978, pp.572–7; Hoozee 1979, No.587.
Yale Center for British Art (Paul Mellon Collection), New Haven

No.10 is based on a drawing by Lionel Constable in the Fogg Art Museum, Harvard University (Fig.vi, 7 × 10 ins.), which is inscribed in his hand 'May the 15 noon [. . .] looking over to Harrow'. The illegible section of the inscription appears to have indicated the year. No.11 below and a related drawing in the 1849 sketchbook (No.43) present a similar view, the middle and far

Fig.vi

distance being fairly close to those in No.10.

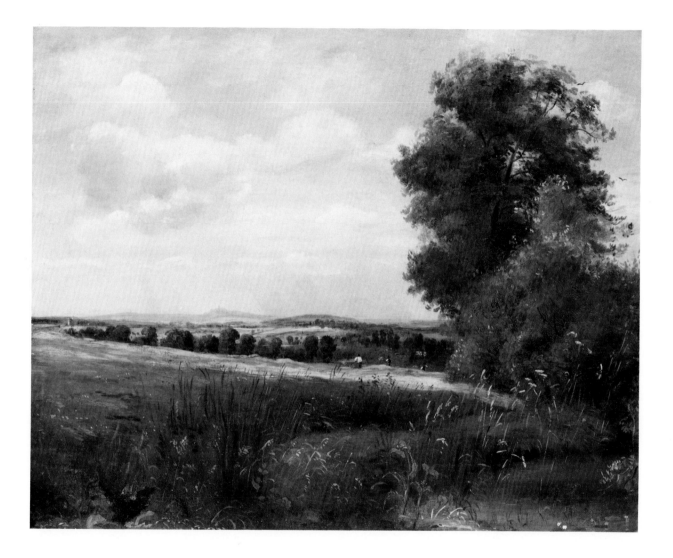

11 HAMPSTEAD HEATH WITH HARROW IN THE
DISTANCE 1849 or after

Oil on (?) paper laid on canvas, $9 \times 11\frac{1}{2}$ (22.9 × 29.2)
Attr: JC until 1978.
Prov: said to be from the collection of Hugh Constable and probably
sold by him to Leggatt's 1899; . . .; Alexander Young, from whom bt.
by Agnew's 1906; . . .; Sir Gervase Beckett, Bart. by 1937; thence by
descent.
Exh: ? Leggatt's 1899 (11 or 27 or 61); Wildenstein 1937(41).
Lit: P. & F-W. 1978, p.577.
Private Collection

The spire of Harrow church can be seen on the highest of the three distant
hills. The left-hand three-quarters of this painting correspond to p.13 in
the 1849 sketchbook (No.43). No.10 above presents a similar view.

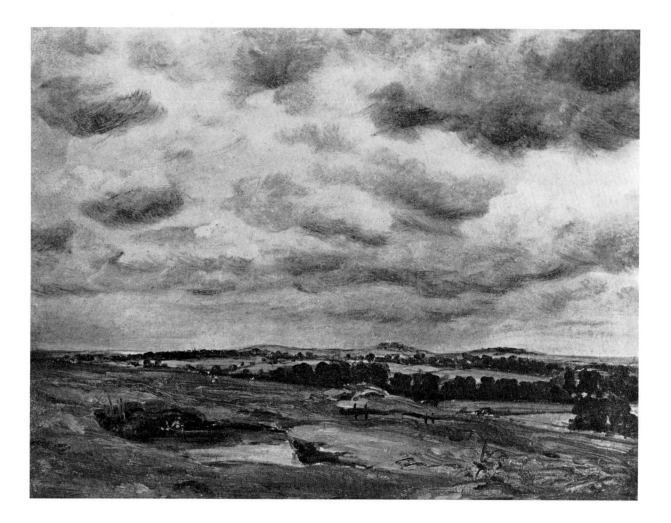

12 HAMPSTEAD HEATH ? ('View near Dedham') 1849 or after

Oil on canvas, $13\frac{1}{2} \times 16\frac{1}{2}$ (34.3 × 41.9)
Attr: JC until 1978.
Prov: . . .; Allen Stuyvesant; purchased from John Nicholson by Smith
College Museum of Art 1950.
Exh: *Paintings and Drawings from the Smith College Collection*,
Knoedler, New York 1953(34); *Constable*, University of Wisconsin,
Milwaukee 1976(13).
Lit: P. & F-W. 1978, p.577; Rhyne 1978, pp. 93, 95; Hoozee 1979,
No.582.
Smith College Museum of Art, Northampton, Massachusetts

This painting is closely related to three pages in the 1849 sketchbook: Nos.37 and 40 below and a further page (p.24) not included in the exhibition (Fig.vii, $3\frac{3}{8} \times 4\frac{13}{16}$ in). The latter is a slight sketch extending to the right the composition seen in Nos.37 and 40. The painting includes this extension.

Fig.vii

The scene depicted in No.12 does not look like a 'View near Dedham', as the painting has been called in the past. The 1849 sketchbook includes two draw-ings definitely made at Hampstead and this painting could well be a Hampstead view.

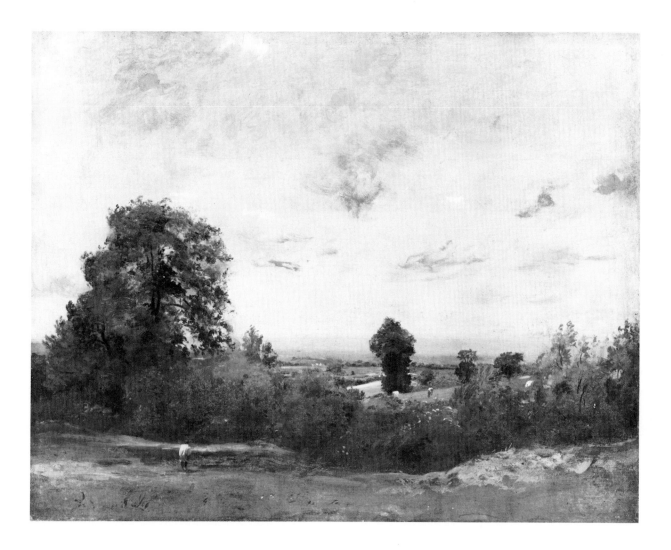

13 HAMPSTEAD HEATH ? ('Vale of Dedham') 1849 or after

Oil on canvas, $14\frac{3}{4} \times 18\frac{3}{4}$ (37.5 × 47.6)
Attr: JC until 1978.
Prov: said to be from the collection of Hugh Constable; Sedelmeyer,
Paris (seal on back); ...; H. L. Fison 1926 and sold by his executors,
Christie's 6 November 1959(23), bt. Agnew.
Lit: P. & F-W. 1978, p.577; Hoozee 1979, No.589.
Private Collection

No.13 is related to p.18 of the 1849 sketchbook (No.36). As with No.12,
the old title – 'Vale of Dedham' – is unconvincing and the subject is more
likely to be a view at Hampstead. The bank at the left and the windmill in
the centre middle distance do not occur in the sketchbook drawing but
may have been suggested by similar features in John Constable's 'West
End Fields' composition, engraved by David Lucas as 'Noon'.

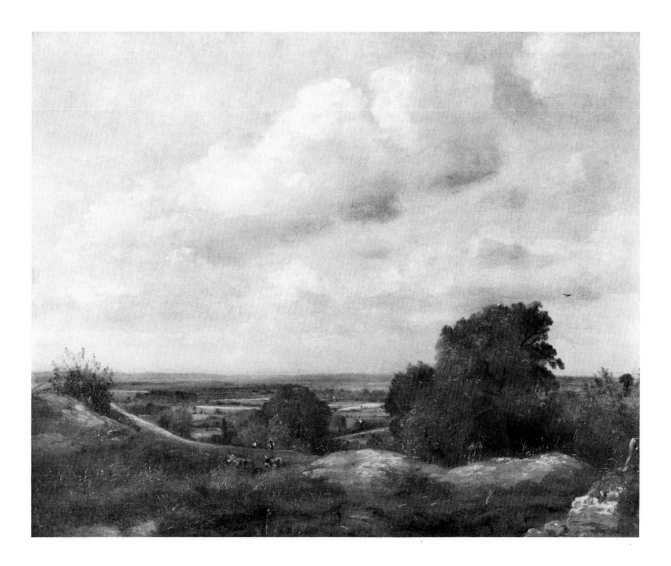

14 'ON THE STOUR' 1849 or after

Oil on paper laid on canvas, $9\frac{3}{4} \times 12\frac{1}{4}$ (24.8 × 31.1)
Attr: JC until 1982.
Prov: sold by Hugh Constable to Leggatt's 1899 (according to their
printed label on the back); . . .; Leggatt's 1952; . . .; anon. sale,
Christie's 9 April 1954(97), bt. Eyton; . . .; purchased from Leggatt's
by present owner 1955.
Exh: Leggatt's 1899(62, 'On the Stour, Suffolk'); *Summer Exhibition*,
Leggatt's 1952(43).
Private Collection

This painting is closely related to p.11 in the 1849 sketchbook (No.41).
None of the drawings in the sketchbook is known to have been made in
Suffolk and there is no evidence that Lionel went there that year: the old
title of No.14 may be inaccurate. There appears to be a connection
between the subject of No.14 and the 'Near Stoke-by-Nayland' com-
position (see No.16) but it is not known whether the latter is in fact a
Suffolk scene.

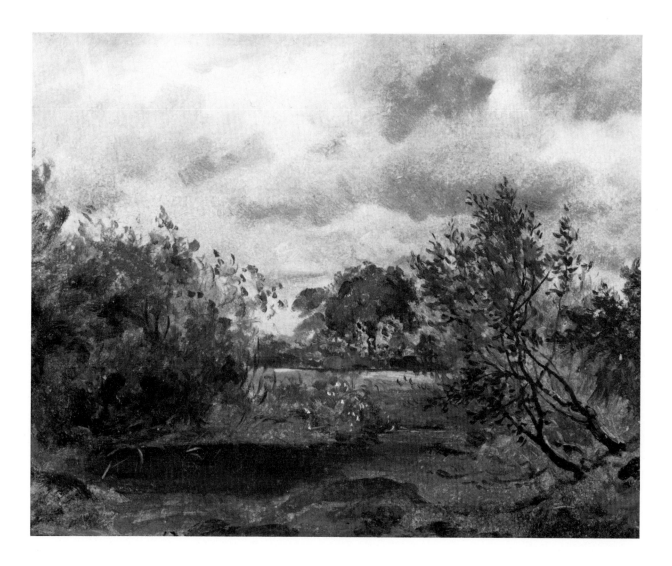

15 'THE WAY TO THE FARM'

Oil on canvas, 16¼ × 14 (41.3 × 35.6)
Attr: JC until 1982.
Prov: sold by Clifford Constable to Leggatt's (according to their ms.
label on the back) before 1904 (when Clifford died); . . . ; Sir Michael
Sadler by 1913 and until *c*.1937; purchased from Spink & Son Ltd 1937
by grandfather of present owner.
Exh: Leeds 1913(108); Wildenstein 1937(26).
Lit: Shirley 1937, pp.lxi, 37.
Private Collection

No.15 depicts the same farmhouse as is seen, from the opposite side, in
one of Lionel's photographs, No.60 below.

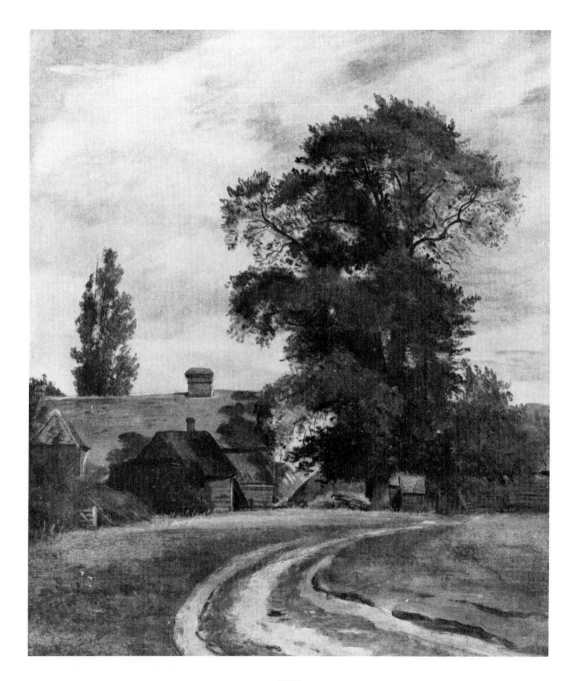

16 'NEAR STOKE-BY-NAYLAND'

Oil on canvas, $14 \times 17\frac{1}{2}$ (35.6 × 44.5)
Attr: JC until 1978.
Prov: possibly one of the works acquired from John Constable's grandchildren by Leggatt's and included in their 1899 exhibition; George Salting by 1902 and bequeathed by him to the National Gallery 1910; transferred to the Tate Gallery 1968.
Exh: ? Leggatt's 1899(40, 'At Stoke by Neyland, Suffolk': see Parris 1981 for further discussion); *The Collection of Pictures and Drawings of the late Mr George Salting*, Agnew's 1910(10); *Constable: The Art of Nature*, Tate Gallery 1971(93).
Lit: Holmes 1902, p.241; Shirley 1937, p.36; P. & F-W. 1978, pp.577–8; Hoozee 1979, No.585; Parris 1981, No.53.
Tate Gallery

Nos.16–33 are paintings attributed to Lionel Constable on stylistic grounds. As explained earlier, only a few specific stylistic features are indicated in the entries on these works. However, because 'Near Stoke-by-Nayland' was such a key picture in the rediscovery of Lionel's work, the arguments for its attribution are summarised again here: the trees are painted in a very similar way to those in 'Tottenham Park' (No.1) and 'Looking over to Harrow' (No.10); the left foreground, with its scattering of tall grasses over a brownish underpainting, is comparable with the foregrounds of 'Looking over to Harrow' and 'On the Sid near Sidmouth' (No.6); the distinctive italic 'f' notation used by Lionel for some of the grasses in these two works is also found in No.16; Lionel's pinky-mauve tones can be seen in the sky; the tiny figures and the mole-hills are disposed in a formal manner which is untypical of John Constable but can be seen in the placing of the figures and the middle-distance trees in 'Looking over to Harrow' and in one of the 1849 sketchbook drawings (No.45 below, with its rows of hay-stooks).

After the publication of the 1978 *Burlington Magazine* article, Richard Constable, great great grandson of John Constable, discovered that his grandfather, Hugh, had attributed No.16 to Lionel Constable in his copy of André Fontainas' *Constable* (1927), where the work is

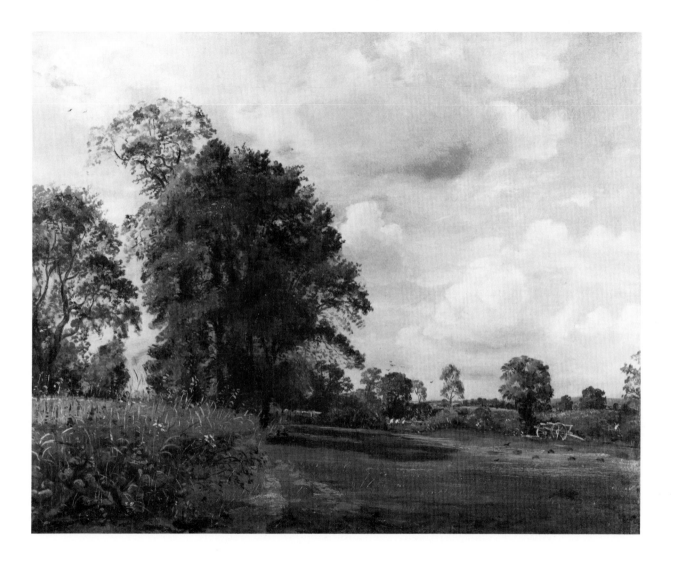

reproduced, but it is not known what led him to this conclusion.

There are traces of squaring-up beneath the paint surface of No.16, which may suggest that it was copied from the nearly identical painting now in the Neue Pinakothek, Munich (No.17). The absence from the latter of the cart, mole-hills and all but one of the birds seen in the Tate picture lends support to the idea that the Munich version was painted first and that No.17 is Lionel's later elaboration of the composition.

Two other works by Lionel depict the same subject as Nos.16–17: an oil study in a private collection and a drawing, No.51 below. Neither appears to have played a direct role in the painting of the two finished versions.

There is a resemblance between the view seen through the gap in the bushes in the centre middle-distance of the 'Near Stoke-by-Nayland' composition (where the three figures are in No.16) and the subject known as 'On the Stour' (No.14, based on the watercolour No.41). The privately owned oil study mentioned in the last paragraph is especially close to 'On the Stour' in this respect. The description of No.16 as a view at or near Stoke-by-Nayland appears to date at least from the time of Leggatt's exhibition in 1899 but it may not be accurate. As explained under No.14, there is reason to doubt that 'On the Stour' is in fact a Suffolk subject.

17 'NEAR STOKE-BY-NAYLAND'

Oil on paper or canvas, 14 × 17½ (35.6 × 44.5)
Attr: JC until 1978.
Prov: . . . ; purchased from the Heinemann Gallery, Munich by
Reichsrat Franz von Bühl, Deidesheim; presented by him to the
Bayerischen Staatsgemäldesammlungen, Munich 1910.
Lit: P. & F-W. 1978, pp.577–8; Hoozee 1979, No.586; Parris 1981, under Nos.53–4.
Bayerischen Staatsgemäldesammlungen, Munich

See the entry on No.16, which is a more elaborate version of this picture.

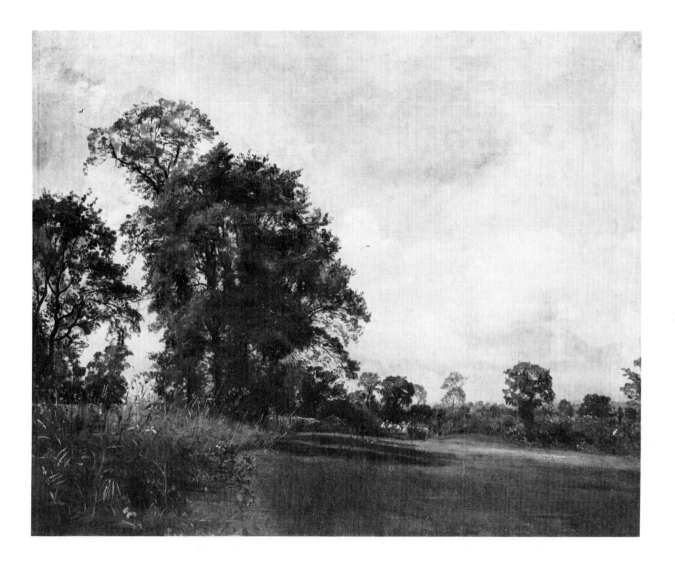

18 ON THE BRENT

Oil on canvas, $12\frac{1}{8} \times 13\frac{1}{4}$ (30.8 × 33.7)
Attr: JC until 1982.
Prov: . . . ; said to be from the collection of Lady Crofton, daughter of
Burton Archer-Burton; . . . ; purchased from Robert Dunthorne & Son
Ltd, April 1938, by father of present owner.
Private Collection

In its subject and general treatment this painting is very close to
'Tottenham Park' (No.1) and the handling of the water, with its ducks
and weeds, is especially so. The inclusion of a distant, white-clad figure is
also typical of Lionel. Comparable studies of silhouetted horses can be
found on p.29 of the 1849 sketchbook.

The river Brent flows through Hertfordshire and Middlesex, joining
the Thames at Brentford. See No.50 for a drawing made on the same
river.

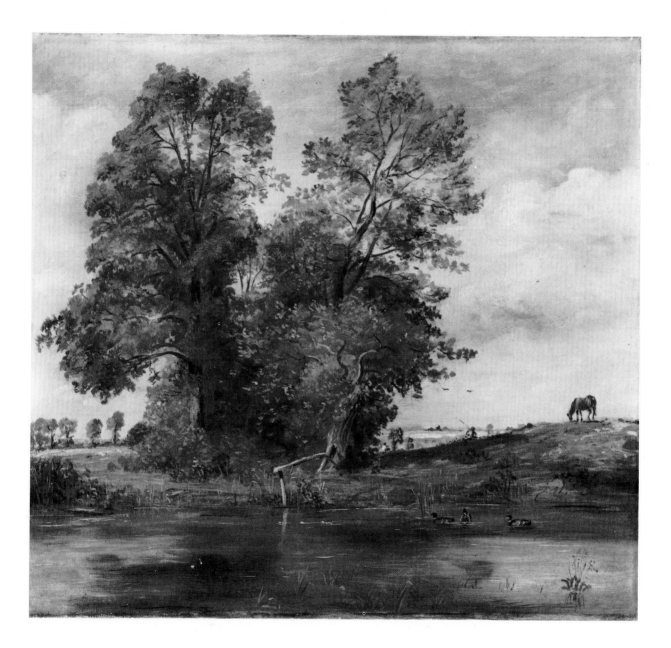

19 COAST SCENE

Oil on canvas, $14\frac{3}{16} \times 18\frac{1}{2}$ (36 × 47)
Attr: JC until 1941 when omitted from *John G. Johnson Collection, Catalogue of Paintings*; attr. to Lionel or Alfred Constable by Hoozee 1979.
Prov: . . .; Sedelmeyer, Paris (seal on back); . . .; J. G. Johnson by 1914.
Lit: Hoozee 1979, No.591.
The John G. Johnson Collection, Philadelphia
[not available for exhibition]

The rocks here are very similar to those in Nos.2–4, while the foreground grasses have Lionel's characteristic calligraphic form (cf. Nos.6, 10). In the past the painting has been called 'The Beach near Yarmouth' but, in view of what is known of Lionel's movements, the subject is more likely to be on the south coast, perhaps in Devon or Cornwall. Lionel, like all his brothers, had been interested in shipping since he was a boy; the highly detailed rendering of ships in No.19 reflects this interest.

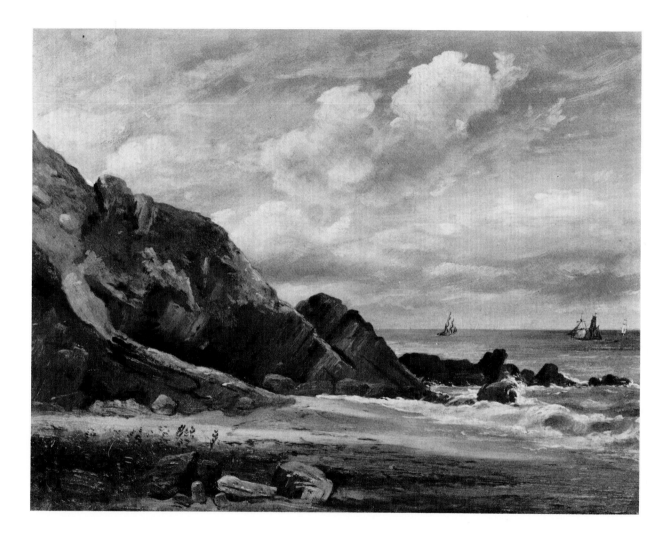

20 'COTTAGE ON THE STOUR, FLATFORD'

Oil on paper laid on canvas, $9\frac{9}{16} \times 15\frac{9}{16}$ (24.3 × 39.5)
Attr: JC until 1982.
Prov: probably sold by Hugh Constable to Leggatt's 1899; . . . ;
Sedelmeyer, Paris (seal on back); . . . ; J. G. Johnson by 1911.
Exh: ? Leggatt's 1899(71, 'Cottage on the Stour, Flatford': the title by
which it has been known in the Johnson Collection).
The John G. Johnson Collection, Philadelphia

The spiky outer leaves on the main group of trees are close to those in the
Carstairs version of 'A Bridge on the Mole' (see Fig.v under No.9); some
of the grasses to the right of the trunk of the thickest tree have Lionel's
characteristic italic 'f' shape. The old title is puzzling. If there is a
waterway concealed behind the rising ground, it must surely be a canal,
not a river, and the subject is therefore unlikely to be on the Stour.
Certainly, there is nowhere at Flatford like this.

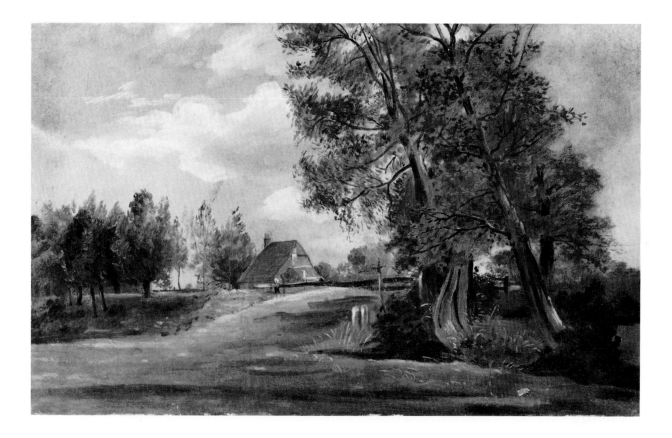

21 'KESWICK LAKE'

Oil on paper laid down on board, $8\frac{15}{16} \times 11\frac{11}{16}$ (22.7 × 29.7)
Attr: JC until 1979 when queried by Hoozee.
Prov: sold by Clifford Constable to Leggatt's 1899 (according to their
printed label on the back); . . . ; Sir Michael Sadler by 1913; . . . ; The
Master of Kinnaird; purchased from Spink & Son Ltd. by Mr and Mrs
Paul Mellon 1961.
Exh: Leggatt's 1899(66, 'At Keswick, Cumberland'); Leeds 1913(105);
Richmond 1963(89); R.A. 1964–5(71); Yale 1965(34); Washington
1969(4).
Lit: Holmes 1902, p.240; Shirley 1937, pp.lxiii, 25, 36; Hoozee 1979,
No.38; Parris 1981, under No.45.
Yale Center for British Art (Paul Mellon Collection), New Haven

This is one of several oils previously associated with John Constable's
visit to the Lake District in 1806 but which now seem more likely to be by
Lionel. The work has a good deal of the bright blue and pinky-mauve
colour favoured by him and the painting of the rocks in the foreground is
close to the way rocks are depicted in his 'Falls of the Tummel' and
Cornish coast scenes (Nos.5, 2–4). In 1902 Sir Charles Holmes made an
interesting comment on No.21 and a companion 'Keswick' subject which
had also been included in Leggatt's 1899 exhibition. Although accepting
them as works by John Constable of 1806, he described them as 'Thin,
smooth, and clever experiments in bright natural colour. Their style is
thus absolutely different from the other paintings of this year.' The
present title of No.21 goes back to at least 1899 but may not be accurate:
the subject could even be a view in Scotland rather than the Lake
District.

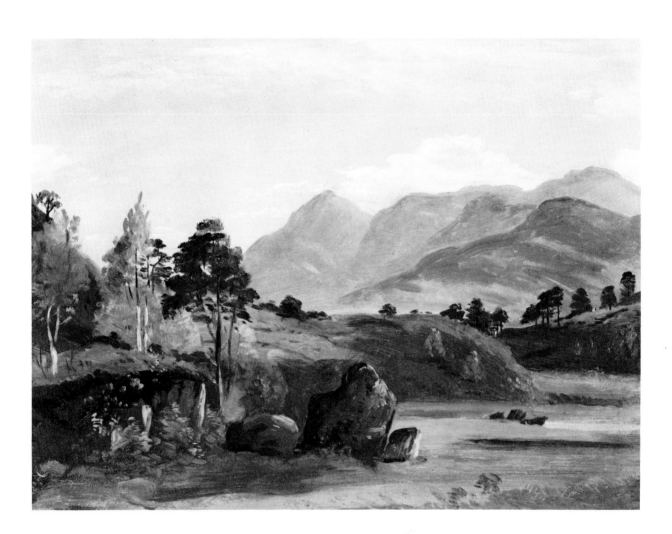

Oil on paper, $9\frac{9}{16} \times 15\frac{1}{2}$ (24.3 × 39.4), originally glued to an oak panel but transferred to synthetic board 1958.
Attr: JC until 1937 when rejected by Shirley; JC from 1956 until 1979 when attr. by Hoozee to Lionel or Alfred Constable.
Prov: . . . ; bequeathed by George Salting to the National Gallery 1910; transferred to the Tate Gallery 1919.
Exh: *The Collection of Pictures and Drawings of the late Mr George Salting*, Agnew's 1910(255); *A Decade of English Naturalism 1810–1820*, Norwich Castle Museum 1969 and Victoria and Albert Museum 1970(3).
Lit: Shirley 1937, pp.lxiii, lxxxiv; Hoozee 1979, No.593; Parris 1981, No.45.
Tate Gallery

Like No.21, this is one of the oil paintings previously thought to have been painted on or following John Constable's tour of the Lake District in 1806. The colours employed in it and the manner in which the rocks are painted strongly suggest Lionel, however. In his private notes Hugh Constable, John's grandson, firmly ascribed it to Lionel, though he gave no reasons. Slight reservations about the attribution to Lionel are expressed in Parris 1981, mainly because John Constable is known to have visited and drawn Thirlmere whereas no other evidence has been found to show that Lionel ever went there. However, the affinities between No.22 and Lionel's certain work now seem too close for the attribution to be any longer doubted.

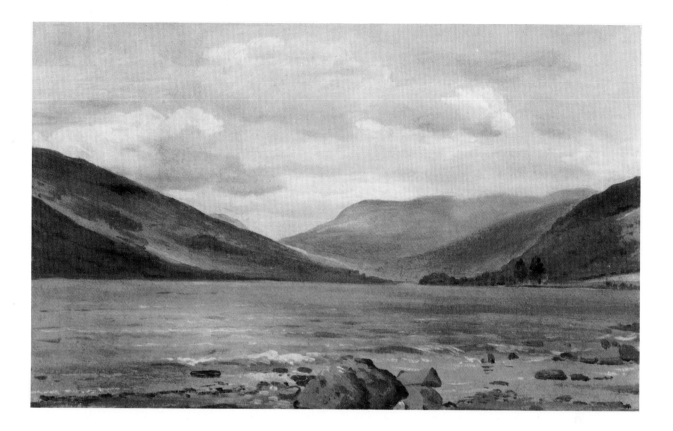

23 LANDSCAPE WITH WINDMILL

Oil on paper, $9\frac{1}{4} \times 14\frac{1}{2}$ (23.5 × 36.8)
Attr: JC until 1979.
Prov: . . .; bequeathed to the Corporation of London by Charles Gassiot 1902.
Exh: *John Constable 1776–1837*, Guildhall Art Gallery 1952(37).
Lit: Hoozee 1979, No.572.
Guildhall Art Gallery

See No.7 for a similar landscape with a windmill. Dr Hoozee illustrates a 'View in Sussex' (No.573) which is not unlike Nos.7 and 23. West Kent or East Sussex do seem possible areas for scenes such as these.

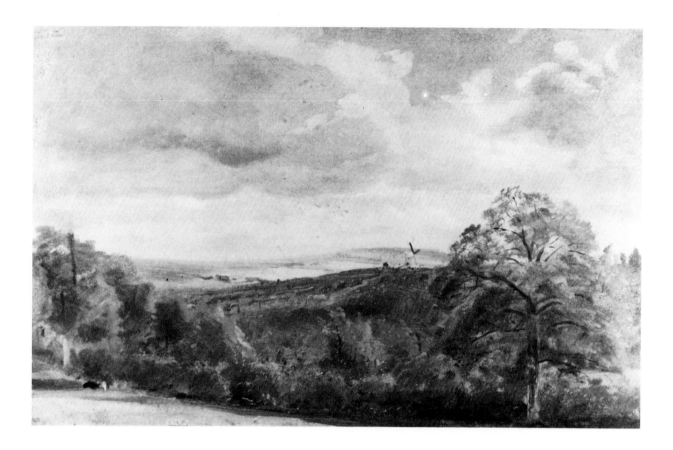

24 LANDSCAPE WITH BRIDGE

Oil on board, $9\frac{7}{8} \times 14\frac{7}{8}$ (25.1 × 37.8)
Attr: JC until 1982.
Prov: . . . ; purchased from Colnaghi's by Leggatt's, July 1946 and sold
to a private collector, by whom resold to Leggatt's 1952; sold by
Leggatt's the same year to an American collector; acquired by the
present owner in New York 1976.
Exh: *Summer Exhibition*, Leggatt's 1952(37).
Private Collection

Although slighter and more loosely painted, No.24 is remarkably close in
subject and character to 'A Bridge on the Mole' (No.9).

25 WOODED LANDSCAPE

Oil on board, $10 \times 14\frac{15}{16}$ (25.4 × 38)
Attr: JC until 1982.
Prov: . . .; purchased from Colnaghi's by Leggatt's, July 1946 and sold
to a private collector, by whom resold to Leggatt's 1952; sold by
Leggatt's the same year to an American collector; acquired by the
present owner in New York 1976.
Exh: *Summer Exhibition*, Leggatt's 1952(35).
Private Collection

This is an unusual subject for Lionel Constable as we know him so far but
the work is full of familiar handling and touches.

26 STUDY OF CLOUDS WITH A LOW HORIZON

Oil on paper laid on panel, 9 × 11⅜ (22.8 × 28.9)
Attr: JC until 1979.
Prov: . . . ; Agnew's; Dr H. A. C. Gregory, sold Sotheby's 20 July
1949(120), bt. Agnew's for Bristol City Art Gallery.
Exh: *John Constable*, Aldeburgh Festival 1948(12); *Sketches &
Drawings by John Constable from the Collection of Dr H. A. C. Gregory,
M.C.*, Arts Council 1949(11); *Pictures from Bristol*, Wildenstein
1969(29).
Lit: Hoozee 1979, No.581.
The City of Bristol Museum and Art Gallery

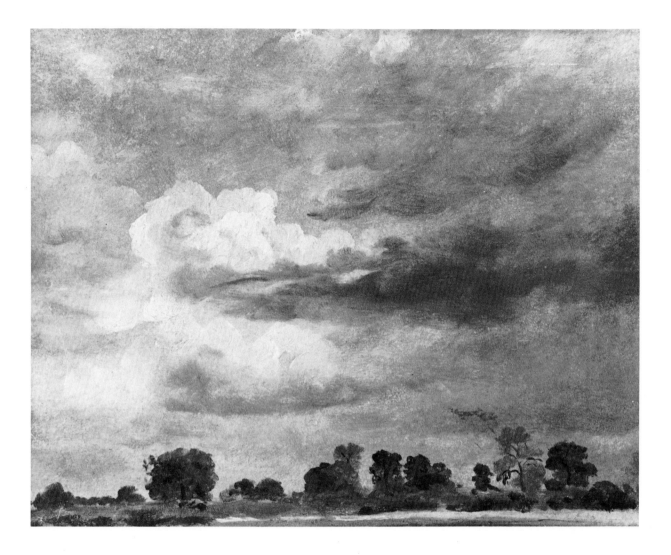

27 VIEW AT HAMPSTEAD, LOOKING TOWARDS HARROW

Oil on canvas, $9\frac{7}{16} \times 14\frac{3}{16}$ (24 × 36)
Attr: JC until 1979, when attr. by Hoozee to Lionel or Alfred Constable.
Prov: said to be from the collection of Hugh Constable; . . . ; bequeathed to the Ashmolean Museum by Mrs W. F. R. Weldon 1937.
Lit: Hoozee 1979, No.597.
The Visitors of the Ashmolean Museum, Oxford

28 'VIEW IN WILTSHIRE'

Oil on canvas, $8\frac{3}{4} \times 11\frac{3}{4}$ (22.2 × 29.9)
Attr: JC until 1982.
Prov: . . . ; Knoedler, London 1929; . . . ; A. Cronin Fleuret; R. S. Clark,
Paris; . . . ; sold by Knoedler to Adams Brothers 1937; . . . ; Percy
Moore Turner by 1944 and thence by descent to the present owner.
Lit: Andrew Shirley, *John Constable, R.A.*, 1944, pl.158 and note on
p.xiv (p.26 in 1948 reprint).
Private Collection

Nos.28–33 exhibit fewer of Lionel's characteristics than are to be seen in
the preceding items. When we know more of the range of his work, they
may fall more convincingly into place.

29 A VALLEY VIEW ('Summer Landscape near Dedham')

Oil on panel, $5\frac{1}{8} \times 9$ (13×22.9)
Attr: JC until 1979, when attr. by Hoozee to Lionel or Alfred Constable.
Prov: . . .; Mrs H. De Beer, from whom purchased by Colnaghi's 1962 and sold to Mr and Mrs Paul Mellon.
Exh: Richmond 1963(107); R.A. 1964–5(73); Yale 1965(36); Washington 1969(25).
Lit: Hoozee 1979, No.590.
Yale Center for British Art (Paul Mellon Collection), New Haven

30 VALLEY SCENE

Oil on paper or board laid on panel, $6\frac{5}{16} \times 7\frac{5}{16}$ (16 × 18.6)
Attr: JC until 1982.
Prov: . . .; Percy Moore Turner; H. A. Sutch, from whom purchased by
K. R. Thomson 1956.
Exh: on loan to Art Gallery of Ontario 1967–71.
David K. R. Thomson

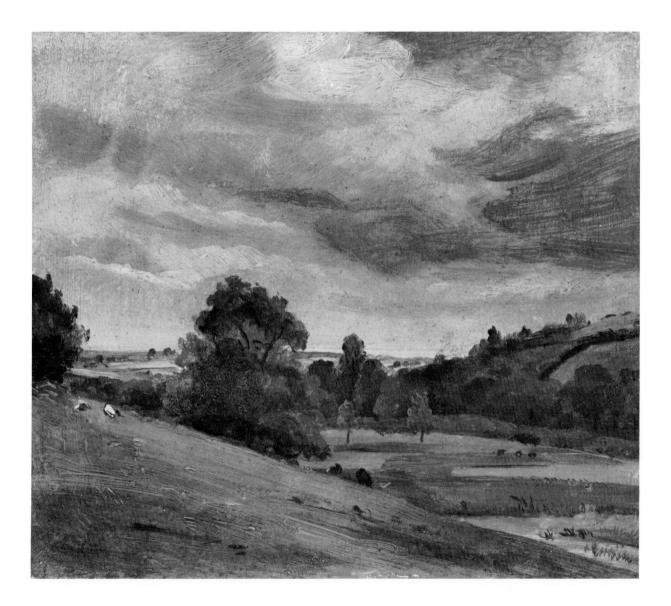

31 'VIEW IN KENT'

Oil on paper laid on panel, $7\frac{11}{16} \times 10\frac{3}{16}$ (19.5 × 25.9)
Attr: JC until 1982.
Prov: . . .; Alexander Young, from whom purchased by Agnew's
1906; . . .; Percy Moore Turner by 1937; H. A. Sutch *circa* 1955;
purchased from Mrs H. A. Sutch by present owner 1976.
Exh: Wildenstein 1937(24).
Lit: Shirley 1937, p.34.
David K. R. Thomson

Nos.31 and 32 are two of four known versions of the subject, which has
been variously called 'View in Kent' and 'View in Wiltshire'. Of the other
two versions, one was in the collection of Lady Eden (exh. Wildenstein
1937, No.23) and the other was sold from the collection of Baron
Heinrich von Sodem at Sotheby's on 14 July 1976(90, repr.; Hoozee
1979, No.583). The Eden version includes a windmill as in No.31 and the
von Sodem version a mast on the ridge as in No.32. The latter is the only
one of the four to show trees at the left edge and an exposed strip of
meadow in the foreground.

In 1980 the organisers investigated possible viewpoints in Kent for the
landscape depicted in Nos.31–2. The most promising were a mile or so
to the west and north-west of Hythe, looking towards Tolsford Hill
and Summerhouse Hill, but it was not possible to make a conclusive
identification.

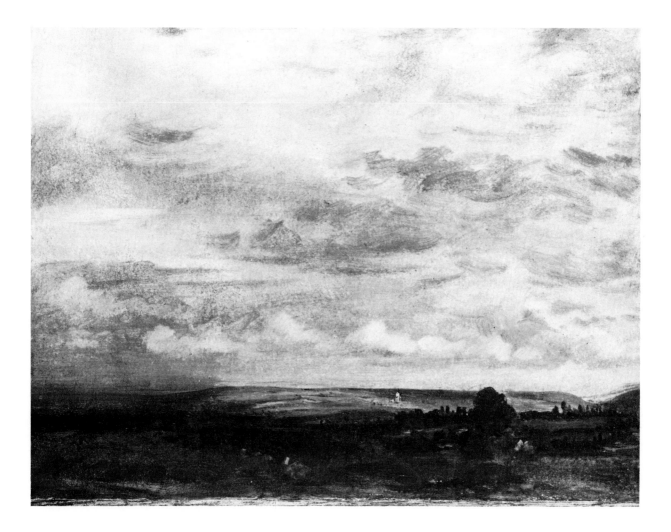

32 'VIEW IN KENT'

Oil on board, $9 \times 11\frac{3}{4}$ (22.9 × 29.9)
Attr: JC until 1982.
Prov: . . .; Knoedler, London 1929; . . .; A. Cronin Fleuret; R. S. Clark;
. . .; sold by Knoedler to Adams Brothers 1937; . . .; Percy Moore
Turner, thence by descent to the present owner.
Private Collection

See the entry on No.31.

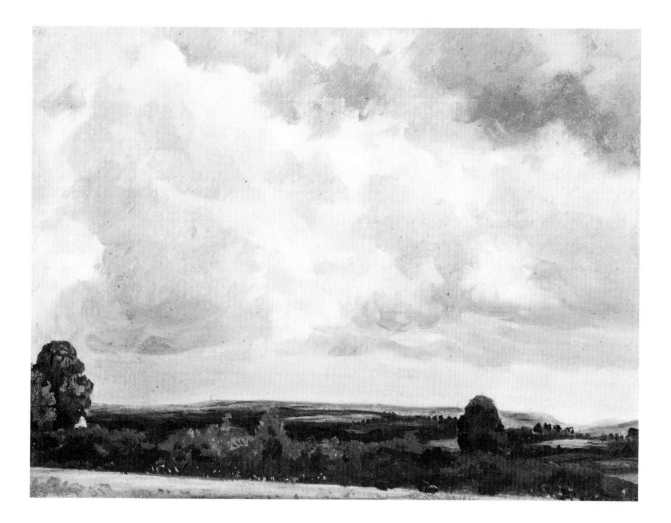

33 AN ASH TREE

Inscribed by Hugh Constable on a label on the back: 'this Study of
A large tree. hedge & part of field measuring $15\frac{1}{2} \times 12$ [. . .]" by
J. Constable R.A. was inherited by me from my aunt Miss Isabel
Constable daughter of the artists Hugh Constable (Grandson of the
artist) London 22.11.1905'.
Oil on paper laid on panel, $15\frac{1}{2} \times 11\frac{3}{4}$ (39.4 × 29.9).
Attr: JC until 1979.
Prov: inherited from Isabel Constable by Hugh Constable and
probably sold by him 1905 (see above); . . .; Sir Michael Sadler by 1913
and until at least 1934; . . .; purchased from Oscar & Peter Johnson
Ltd by Mr and Mrs Paul Mellon 1964.
Exh: Leeds 1913(111); *English Paintings and Drawings circa
1780–1830*, Burlington Fine Arts Club, Winter 1933–4(41); R.A.
1964–5(84); Washington 1969(66).
Lit: Hoozee 1979, No.575.
Yale Center for British Art (Paul Mellon Collection), New Haven

A number of similar studies of single trees were formerly attributed to
John Constable. Some of them, including No.33, may be by Lionel.

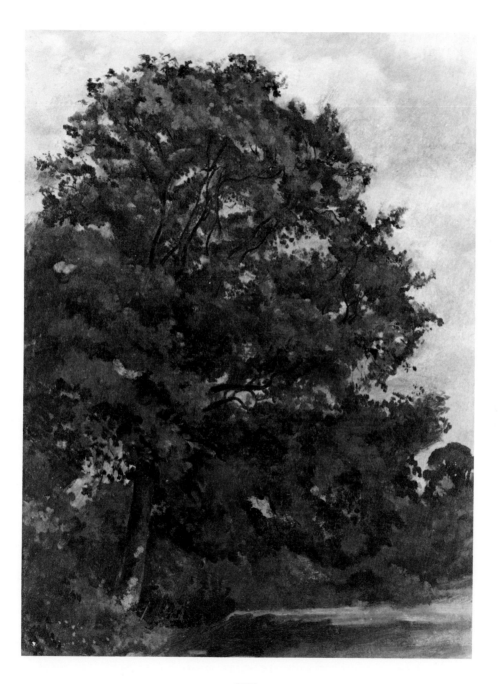

DRAWINGS & WATERCOLOURS

Only a few examples of Lionel Constable's work in pencil and watercolour are presented here. A much larger exhibition would be required to explore this area properly.

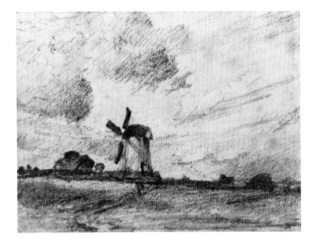

34 A WINDMILL 1846

Inscribed on the back 'I did this on the spot so it is like that kind of mill. The day Minna named for me to come home was Saturday the 10 Oct. but I will write again if I am going but I think I shall go with Mrs Atkinson'; also inscribed in a later hand 'Toby', i.e. Lionel. Pencil, $2\frac{1}{8} \times 3$ (5.4 × 7.6)
Attr: always LBC.
Prov: always in the Constable family.
Exh: ? Ipswich 1954(219); ? Camberwell 1954(143); *Constable: Paintings, Watercolours & Drawings*, Tate Gallery 1976(342).
Lit: Ian Fleming-Williams, *Constable Landscape Watercolours & Drawings*, 1976, pp.12, 122; P. & F-W. 1978, p.571.
Mrs Eileen Constable

Lionel spent part of the summer of 1846 staying with a Mrs Nodin at Ashcott near Glastonbury in Somerset from where he sent drawings to his brother Alfred who was in Suffolk. Alfred wrote to thank Lionel for a 'pretty ⟨. . .⟩ little sketch of the mill in the distance' and on the 24 September told him: 'I showed Uncle [Abram] the pretty little sketch you did me of a little peice of distance with a mill in it ⟨it⟩ he said you had done the mill very nicely'. 'Dear Lar', Alfred wrote again in October, 'I must tell you that the pencilling of the mill you sent me is very beautiful you seem to have quite the power of the pencil the sky is so beautiful how well it will paint do make a sketch of it a grand sky will greatly help you'. The first of the three letters just cited also includes a reference to 'Mrs Atkinson coming' to Lionel, so it is more or less certain that No.34, with its reference to this lady, was the study of the mill that so impressed Alfred. Mrs Atkinson, who may have been the mother of Mary Atkinson, to whom the boys' elder brother John Charles Constable was engaged at the time of his death, was presumably going to collect Lionel from Somerset. The date of No.34 is in any case almost certainly 1846 because 10 October fell on a Saturday that year but not again until 1857. There were a number of tower windmills in the area around Ashcott in the middle of the nineteenth century. A mill very similar to the one depicted in No.34, with an identical thatched gable-shaped cap, may still be seen at High Ham only a few miles away. A larger version of No.34 at Christchurch Mansion, Ipswich used to be attributed to John Constable (repr. Harold Day, *John Constable Drawings*, 1975, pl.58).

Fig.viii

PAGES FROM A SKETCHBOOK 1849

Attr: JC until 1978.
Prov:...; presented by Charles Sedelmeyer 1896.
Lit: P. & F-W. 1978, p.577; Rhyne 1978, passim.
Staatliche Museen zu Berlin

The following drawings and watercolours come from a dismembered sketchbook of 33 pages. Dates inscribed on the pages range from 18 May to 21 September. At an unknown date the year in the inscriptions on some of the drawings was altered from '49' (for 1849) to '19' (for 1819) in an attempt to place the book firmly within John Constable's lifetime. Several of the drawings appear to have been made at Hampstead and two certainly were. As the person responsible for the alterations was probably aware, John Constable did work at Hampstead in 1819, though there is no record of him being there before the late summer. Fig.viii illustrates the altered inscription on p.2 of the sketchbook, a study of a tree at Hampstead (not exhibited). Charles Rhyne (1978, p.92) reproduces the same inscription in colour, showing the alteration more clearly.

35

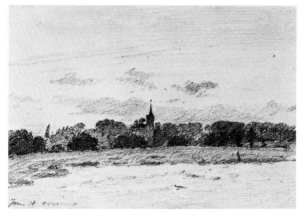

35 LANDSCAPE WITH CHURCH TOWER (Sketchbook p.17)
18 or 28 June 1849

Inscribed 'June [1 or 2]8 evening' bottom left.
Pencil, $3\frac{7}{16} \times 4\frac{7}{8}$ (8.7 × 12.3)

Lionel engraved this subject in mezzotint, either in 1849 or early in 1850 (see No.55).

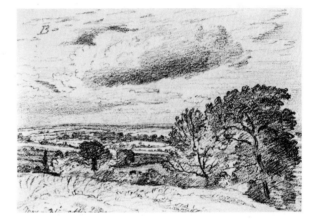

36 LANDSCAPE AT HAMPSTEAD?
(Sketchbook p.18) 21 May 1849

Inscribed 'May 21\underline{t} afternoon' bottom left and 'B' in the sky.
Pencil, $3\frac{7}{16} \times 4\frac{7}{8}$ (8.7 × 12.4)

This drawing is related to a painting at one time in the Fison collection (No.13 above). Two of the drawings in the 1849 sketchbook (p.2, see above; p.13, No.43 below) definitely depict Hampstead subjects and the present drawing could well be a view from Hampstead Heath.

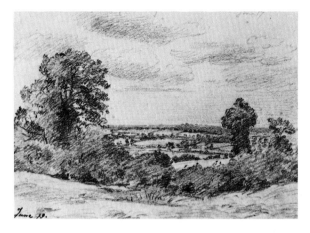

37 LANDSCAPE AT HAMPSTEAD?
(Sketchbook p.19) 17 June 1849

Inscribed 'June 17' top right and 'June 19.'
(altered from '49') bottom left.
Pencil, $3\frac{7}{16} \times 4\frac{7}{8}$ (8.7 × 12.3)

Lionel also made a watercolour of this subject:
No.40 below. Together with a slighter sketch on
p.24, Nos.37 and 40 served as the basis for the oil
painting now in the Smith College Museum (No.12).
As with No.36, the view could well be at Hampstead.

38

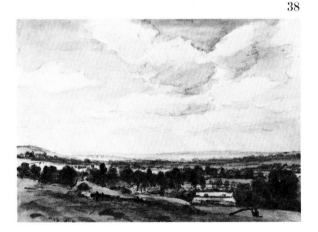

38 LANDSCAPE AT HAMPSTEAD
(Sketchbook p.8)

Watercolour, $3\frac{3}{8} \times 4\frac{13}{16}$ (8.6 × 12.2)

The wooden structure seen towards the centre of this
page appears to be identical to the one in No.43 and
in the related oil painting, No.11. These both depict
views at Hampstead, looking towards Harrow.

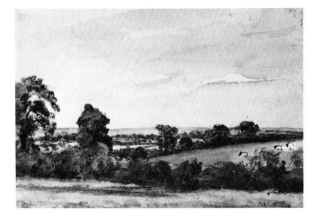

39 LANDSCAPE AT HAMPSTEAD?
(Sketchbook p.9)

Watercolour, $3\frac{3}{8} \times 4\frac{7}{8}$ (8.6 × 12.3)

40 LANDSCAPE AT HAMPSTEAD?
(Sketchbook p.10)

Watercolour, $3\frac{3}{8} \times 4\frac{13}{16}$ (8.6 × 12.2)

A watercolour version of No.37, q.v.

**41 LANDSCAPE WITH TREES AND
POND** (Sketchbook p.11)

Watercolour, $3\frac{7}{16} \times 4\frac{7}{8}$ (8.7 × 12.3)

This page served as the basis for the painting later
known, probably erroneously, as 'On the Stour'
(No.14).

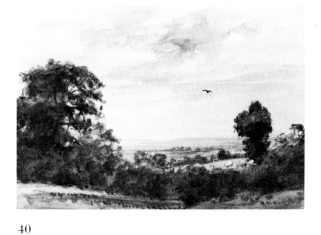

40

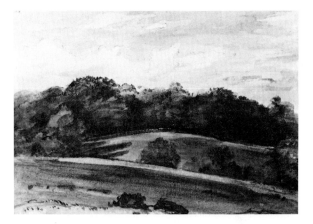

42 LANDSCAPE (Sketchbook p.12)

Watercolour, $3\frac{7}{16} \times 4\frac{7}{8}$ (8.7 × 12.3)

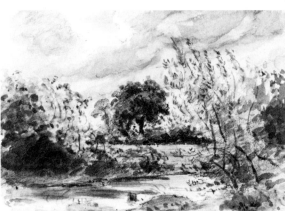

41

43 HAMPSTEAD HEATH, LOOKING
 TOWARDS HARROW
 (Sketchbook p.13) 25 or 26 June 1849

Inscribed 'June 2[5 or 6]th' bottom left.
Watercolour, $3\frac{7}{16} \times 4\frac{7}{8}$ (8.7 × 12.3)

Connected with the painting exhibited here as
No.11, this watercolour shows Harrow Hill in the
distance at the right.

**44 MAN BY A STREAM AT
ELSTREE** (Sketchbook p.20) May 1849

Inscribed 'Elstree. May' bottom left.
Pencil, $3\frac{7}{16} \times 4\frac{7}{8}$ (8.7 × 12.3)

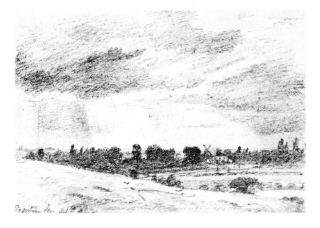

46 LANDSCAPE WITH WINDMILL
(Sketchbook p.22) 21 September 1849

Inscribed 'September 21st [. . .]' bottom left.
Pencil, $3\frac{3}{8} \times 4\frac{13}{16}$ (8.6 × 12.2)

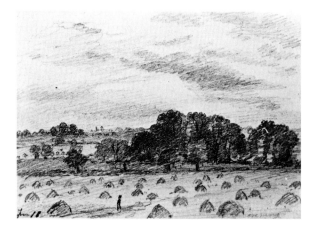

45 FIELD WITH HAY-STOOKS
(Sketchbook p.21) 18 June 1849

Inscribed 'June 18' bottom left and 'evening'
bottom right.
Pencil, $3\frac{7}{16} \times 4\frac{7}{8}$ (8.7 × 12.3)

47 REDDING POINT FROM RAME 1850

Inscribed 'Redding P_.t From Rame in
Cornwall. July 2$^{\underline{nd}}$ 1850.' on the back of the
old mount.
Watercolour, $4\frac{5}{8} \times 7\frac{1}{8}$ (11.7 × 18.1)
Attr: always LBC.
Prov: always in the Constable family.
Exh: Ipswich 1954(175); *The Other Constables*,
Camden Arts Centre 1976(Lionel Constable
No.3).
Mrs Eileen Constable

This is a view inland from Rame, looking over
Cawsand Bay and The Sound towards Plymouth.
The white building seen near the water's edge just
before Redding Point is presumably the fort at
Picklecombe Point. For oil studies made on the same
visit to Cornwall see Nos. 2–4.

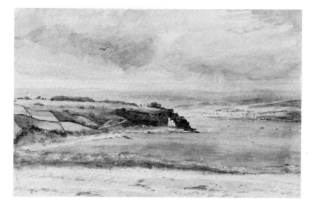

47

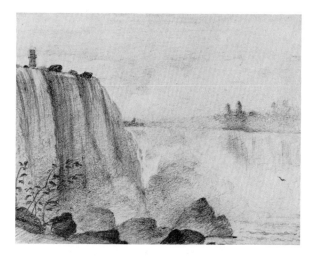

48a

48a NIAGARA FALLS 1850
Inscribed 'niagra' on front of old mount and
'Oct 30\underline{th} 1850' on back of mount.
Pencil, $4\frac{1}{4} \times 5\frac{1}{2}$ (10.9 × 14)

b MILWAUKEE 1850
Inscribed 'milwakee' bottom right
Pencil, $4\frac{1}{4} \times 5\frac{1}{2}$ (10.9 × 14)
Attr: always LBC.
Prov: always in the Constable family.
Exh: Ipswich 1954(207–8); Camberwell
1954(171, 170).
Mrs Eileen Constable

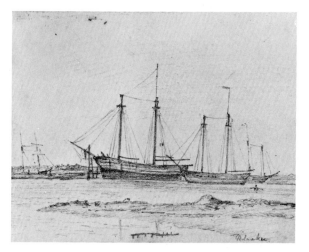

48b

These two drawings and the two letters published on
pp.23–26 are practically the only record of Lionel's
brief visit to America in the autumn of 1850. The
first of the two letters shows that he landed at New
York on 1 October and planned to travel via Albany
and Buffalo to Chicago. In the second letter he men-
tions visiting Milwaukee and taking in Niagara
Falls on his way back to New York, from where he
sailed for London on 16 November. The reason for
his visit is unclear and the identity of his travelling
companion, 'Jack', has not been established.

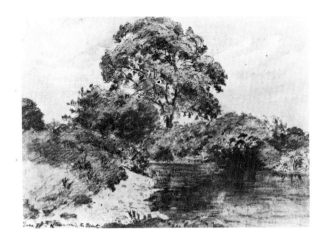

49 WEMYSS BAY 1851

Inscribed on the back 'Weymss Bay. Ayre shire' and, in a different hand, 'Lionel'.
Watercolour, $4\frac{3}{16} \times 5\frac{7}{16}$ (10.7 × 13.9)
Attr: always LBC.
Prov: always in the Constable family.
Exh: ? Ipswich 1954(176).
Mrs Eileen Constable

Lionel visited Scotland in the summer of 1851 and exhibited a painting of the 'Falls of the Tummel' at the R.A. the following year (No.5 above). Another watercolour of Weymss Bay in the family collection is inscribed by Lionel on the back of the mount 'June the 14th Evening on the clyde Wemssbay 1851.'

50 AFTERNOON ON THE BRENT

Inscribed 'June – 8th afternoon – the Brent –' bottom left.
Pencil and watercolour, $7\frac{1}{16} \times 10\frac{3}{16}$ (18 × 26)
Attr: JC until 1978.
Prov: . . . ; F. Hindley Smith by 1937 and

bequeathed by him to Norwich Castle Museum 1940.
Exh: Wildenstein 1937(117)
Lit: Shirley 1937, p.36; Rhyne 1978, p.95.
Norfolk Museums Service (Castle Museum, Norwich)

The inscription is in Lionel Constable's hand. There is a plant study on the back of the sheet. See No.18 for a note on the subject.

51

51 'NEAR STOKE-BY-NAYLAND'

Pencil, $4\frac{9}{16} \times 6\frac{13}{16}$ (11.6 × 17.4)
Attr: JC until 1978.
Prov: one of a group of works sold by Ella
Constable (Mrs Mackinnon) through Leggatt's
in the 1890s to Sir Henry Newson-Smith, Bart.;
sold by his son, Sir Frank Newson-Smith, Bart.,
at Christie's, 26 January 1951(14, with two
others), bt. R. B. Beckett; purchased by the
Tate Gallery from Mrs Norah Beckett 1970.
Exh: *Constable: The Art of Nature*, Tate
Gallery 1971(94).
Lit: P. & F-W. 1978, pp. 577–8; Parris 1981,
No.54.
Tate Gallery

This drawing does not appear to have been used in
any direct way for the painting of the Tate Gallery
and Munich versions of 'Near Stoke-by-Nayland'
(Nos.16–17) but it clearly depicts the same site.

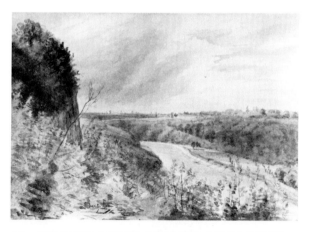

52 ON THE LUNE NEAR LANCASTER

Watercolour, $6\frac{3}{4} \times 9\frac{5}{8}$ (17.2 × 24.4)
Attr: JC until 1976 when called only

'J. Constable' at auction; LBC 1982.
Prov: . . .; anon. sale, Sotheby's 20 November
1963(42), bt. Spink; . . .; anon. sale, Christie's
14 December 1976(56, as 'J. Constable'), bt.
in; . . .; presented to Abbot Hall Art Gallery
by G. D. Lockett 1977.
Abbot Hall Art Gallery, Kendal

In a letter dated only 5 June without year (see p.22),
Lionel told his brother Alfred about a tour of
Derbyshire and Lancashire he was then making.
From this his route appears to have been: Bakewell,
Castleton, Glossop, Manchester, Fleetwood and
Broughton-in-Furness, where he wrote the letter.
No.52 was probably made on the same tour.
Lancaster and the river Lune would have been
visited on the way from Fleetwood to Broughton but
as Lionel claims in his letter to 'have done no
sketches', he may have returned the same way and
made No.52 then.

**53 STUDY OF A TREE IN A
LANDSCAPE**

Watercolour, pencil and ink,
$14\frac{7}{8} \times 11\frac{3}{8}$ (37.8 × 28.9)
Attr: JC until 1981.
Prov: said to be from the collections of Charles
Golding Constable and Eustace Constable and
to have been with Leggatt's, Heinemann
Gallery and Sedelmeyer; P. A. Chéramy,
Paris; Brunner Gallery, Paris, 1910; . . .;
Pierre Dubaut, Paris 1961; . . .; purchased
from Eugene Victor Thaw & Co., Inc., New
York by Mr and Mrs Paul Mellon 1974.
Exh: *L'Aquarelle Romantique en France et an
Angleterre*, Musée des Beaux-Arts, Calais
1961(22).
*Yale Center for British Art (Paul Mellon
Collection), New Haven*

PRINTS

This is the largest known watercolour by the artist. Lionel Constable made many 'full-length' tree studies in pencil and watercolour. The Louvre sketchbook of *c*.1845 (RF 08699)* includes several with horses grazing at their base as in No.53, though this work is likely to be rather later in date.†

*A facsimile of this sketchbook is included in Graham Reynolds, *Constable with his friends in 1806*, due for publication by the Trianon Press and Genesis Publications December 1981. This is a facsimile edition of four sketchbooks in the Louvre, three by John Constable and one by Lionel.

†A full catalogue entry on No.53 is included in Charles Rhyne, 'Constable Drawings and Watercolors in the Collection of Mr and Mrs Paul Mellon and the Yale Center for British Art . . . Part II Reattributed Works', *Master Drawings*, XIX, No.4, due for publication Winter 1981.

54 SHIP IN A STORM

Inscribed on the back by Hugh Constable 'painted (watercolour) & engraved by Lionel Constable' and, in a different hand, 'Lionel'. Mezzotint, $3\frac{1}{8} \times 5$ (8×12.7) to plate mark.
Attr: always LBC.
Prov: always in the Constable family.
Exh: Ipswich 1954(210); Camberwell 1954(156).
Mrs Eileen Constable

A pencil drawing and a watercolour by Lionel of the same subject are in the family collection. Lionel was engaged in print-making, though not necessarily in mezzotinting, as early as 1846. In a letter of 1 April that year his brother Charles, then in Bombay, thanked Isabel for sending 'Toby's little print', a twilight scene which he found 'rather grand'. This print has not been identified.

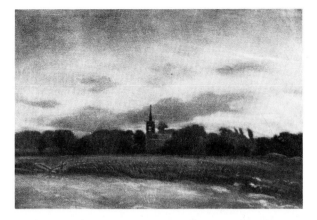

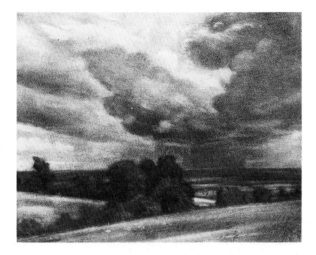

55 LANDSCAPE WITH CHURCH TOWER 1849 or 1850

Mezzotint, $3\frac{1}{4} \times 4\frac{13}{16}$ (8.2 × 12.2) to plate mark.
Attr: LBC 1982.
Prov: probably acquired *c*.1895–1913 by
Ernest Leggatt, from either the Constable or
Lucas families; thence by descent.
Exh: ? Leeds 1913 (part of No.4, as David
Lucas after John Constable).
The Leggatt Family

This is an engraving in reverse of p.17 in the 1849
sketchbook (No.35). An impression in the Constable
family collection is inscribed 'Printed Jan.y 2 by M.r
Lucas.1850'. The mezzotint engraver David Lucas
worked extensively for John Constable and may
have taught Lionel to use mezzotint.

56 STORMY AFTERNOON

Inscribed on the back by Hugh Constable
'Engraved by Lionel Constable from a picture
by his father the R.A.' and 'Title of picture
was "Stormy afternoon"'.
Mezzotint, $3\frac{5}{16} \times 4\frac{1}{16}$ (8.4 × 10.3) to plate mark.

Attr: always LBC.
Prov: always in the Constable family.
Lit: Holmes 1902, repr. p.139 as 'A Shower' by
David Lucas after John Constable.
Mrs Eileen Constable

Another impression of this print in the family
collection is inscribed 'Stormy afternoon' in Lionel's
hand below the plate mark and 'Lionel' on the back.
Despite the reference in the inscription, No.56 may
be an engraving after a composition by Lionel rather
than John Constable.

PHOTOGRAPHS

The earliest known reference to Lionel Constable as
a photographer is in a letter to him from his brother
Alfred dated 10 November 1852. In this Alfred asked
him to make a sketch of a grounded barque which
Lionel had evidently described in an earlier letter:
'what a splendid chance for a Calotype', Alfred

added, 'but I suppose it is no go if there is no sun'. A letter from Charles to Minna of 21 February 1854 refers to Lionel's 'deguerreotypes' and one from Charles to Lionel of 22 July 1854 to four 'sun pictures' by him of a chair, a painting by C. R. Leslie, a windmill and a farmhouse. Further letters from Charles of 1854 and 1856 mention Lionel's portrait photographs of their sister Isabel (see Nos.67–9). Two letters from Lionel to Minna of November 1856 (see pp.27–28) describe Lionel's attempts to find subjects for his camera at Hastings; one mentions his use of collodion. This last reference indicates that Lionel was using the wet-plate process which Frederick Scott-Archer had invented in 1851. Most of Lionel's surviving photographs are consistent with this since they appear to be salt or albumen prints from glass negatives. It is difficult to decide whether the earlier references to calotypes and daguerreotypes should be taken literally; no photographs by Lionel made by these processes have so far been identified (in their 1978 article the organisers incorrectly assumed that Lionel's surviving photographs were calotypes). By 1871 Lionel was a friend of Philip Henry Delamotte, the artist, photographer and author of manuals on drawing and photography, but it is not known when they first became acquainted.

* * *

The following photographs are salt prints with the exception of Nos.60, 63, 70 and 71, which are albumen prints. All are lent by Mrs Eileen Constable and have been selected from a total of about fifty photographs by Lionel which survive in the family collection. Measurements refer to paper size. The organisers are grateful to Valerie Lloyd, Curator of Photographs at the Royal Photographic Society, Professor Harvey Himmelfarb of the University of California and Alice Swan for their advice on this aspect of Lionel's work.

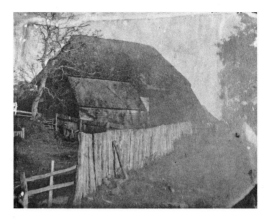

57 AN OLD BARN
$6\frac{1}{8} \times 7\frac{13}{16}$ (15.5 × 19.8)

See No.8 for Lionel's painting of the same subject. Another print from the same negative is inscribed 'by Toby' on the back.

58 A BRIDGE ON THE MOLE
$5\frac{9}{16} \times 8\frac{11}{16}$ (14.1 × 22)

See No.9 for Lionel's two paintings of the subject. Another print from the same negative is inscribed on the back by Hugh Constable 'From a picture by Toby photo by Toby' and 'Holmes says it is a J.C.'

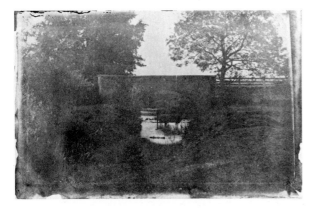

59 A BRIDGE ON THE MOLE, WITH CATTLE IN THE WATER

$5\frac{7}{16} \times 8\frac{9}{16}$ (13.8 × 21.8)

Inscribed on the back by Hugh Constable 'this seems to be the same bridge as in the picture by Toby (or J.C.) but is from life'.

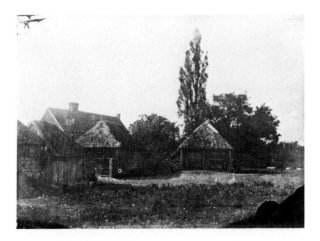

60 A FARM

$6\frac{1}{4} \times 8\frac{3}{4}$ (15.8 × 22.2)

The same farm-house and poplar tree are seen from a different angle in Lionel's painting 'The Way to the Farm' (No.15).

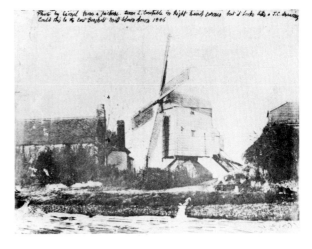

61 A WINDMILL

$6\frac{3}{4} \times 8\frac{11}{16}$ (17.2 × 22)

Signed on the plate 'L Constable'. Inscribed on the front of the print by Hugh Constable 'Photo by Lionel from a picture. ⟨Lione⟩L. Constable in Right hand corner but it looks like a J.C. drawing Could this be the East Bergholt Mill blown down 1886'. Also inscribed on the back 'Taken by Toby from Drawing'. Hugh Constable appears to have been misled by the retouching on the glass negative into thinking that this was a photograph after a drawing rather than one taken from nature. The inscription on the photograph referred to under No.58 above betrays a similar confusion. The windmill has not been identified but it is not the East Bergholt mill.

62 A MAN SITTING OUTSIDE A
 COTTAGE
$5\frac{13}{16} \times 6\frac{7}{16}$ (14.7 × 16.3)

63 THE BACK GARDEN OF
 (?) 16 CUNNINGHAM PLACE
$5\frac{1}{2} \times 6\frac{11}{16}$ (14 × 17)

Inscribed on the back by Hugh Constable 'prob-
ably back garden 16 Cunningham Place Hamilton
Terrace (The Aunts & Toby) next to Blundells'. This
was the address to which the Constable children
moved in 1838. Lionel, Minna and Isabel later went

to 64 Hamilton Terrace. The Blundells were
presumably the parents-in-law of Lionel's brother
Charles, who married Anna Maria Blundell in 1863.

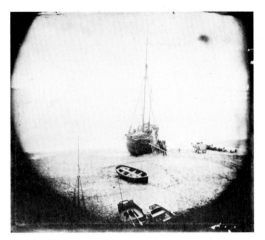

64 A BEACHED BOAT
 $7\frac{7}{16} \times 8\frac{11}{16}$ (18.9 × 22)

65–6 A HARTSHORN FERN AND
 ANOTHER FERN
 Each $8\frac{11}{16} \times 6\frac{7}{16}$ (22 × 16.3)

No.65 is a negative photogenic drawing, made by
direct contact with the objects. No.66 is a positive
print from No.65.

67

68

69

70

67 ISABEL CONSTABLE, FACING RIGHT

$5\frac{1}{2} \times 3\frac{9}{16}$ (14 × 9)

Inscribed 'Isy' on the back. Outliving all her brothers and sisters, Isabel (1822–88) inherited the larger part of the family collection of John Constable's work, from which she made generous gifts and bequests to the nation in 1887–8. Photographs of Isabel by Lionel are mentioned in letters from Charles to Minna of 21 September 1854 and from Charles to Isabel of 29 July 1856. In the latter Charles wrote: 'By the by I recd your portrait done I suppose by Lar, it was, of course like, but I must confess I do not like the sun pictures – portraits – I mean – there is always something so heavy about the mouth, & the dark shade of the eyes, or one thing and the other – a pencil sketch is far more pleasing'.

68 ISABEL CONSTABLE, FACING
 FORWARDS
 $4\frac{1}{2} \times 4\frac{7}{16}$ (11.5 × 11.2)

Inscribed by Hugh Constable on the back 'Probably
Isabel'.

69 ISABEL CONSTABLE, FACING LEFT
 $4\frac{5}{8} \times 3\frac{7}{16}$ (11.7 × 8.7)

Inscribed 'Isy' on the back.

70 LIONEL CONSTABLE
 Unknown Photographer
 $5\frac{1}{2} \times 4\frac{5}{16}$ (14 × 10.9)

Inscribed 'Toby' on the back.

71 LIONEL CONSTABLE
 Photograph taken by Barrauld & Jerrard
 $5\frac{9}{16} \times 4$ (14.1 × 10.2) on cabinet card printed
 with photographer's name and address.

Inscribed on the back 'June 1872 1–of this for my-
self – Lionel Constable'. Inscribed by Hugh
Constable on the front of the card 'Lionel Bicknell
Constable (Toby)' and, in a different hand, '1872
June'.

71

LIST OF LENDERS

Abbot Hall Art Gallery, Kendal 52
Ashmolean Museum, Oxford 4, 27
Bayerischen Staatsgemäldesammlungen,
 Munich 17
City of Bristol Museum and Art Gallery 26
Mrs Eileen Constable 1–3, 5, 7, 34, 47–9, 54, 56,
 57–71
Guildhall Art Gallery 23
John G. Johnson Collection, Philadelphia 9,
 19–20
Leggatt Family 55
Norfolk Museums Service (Castle Museum,
 Norwich) 50
Private Collections 11, 13–15, 18, 24–5, 28, 32
Smith College Museum of Art, Northampton,
 Massachusetts 12
Staatliche Museen zu Berlin 35–46
Tate Gallery 16, 22, 51
David K. R. Thomson 30–1
Yale Center for British Art (Paul Mellon
 Collection), New Haven 6, 8, 10, 21, 29, 33, 53

UXBRIDGE COLLEGE
LEARNING CENTRE